IMAGES
of America

SALT LAKE CITY
1890–1930

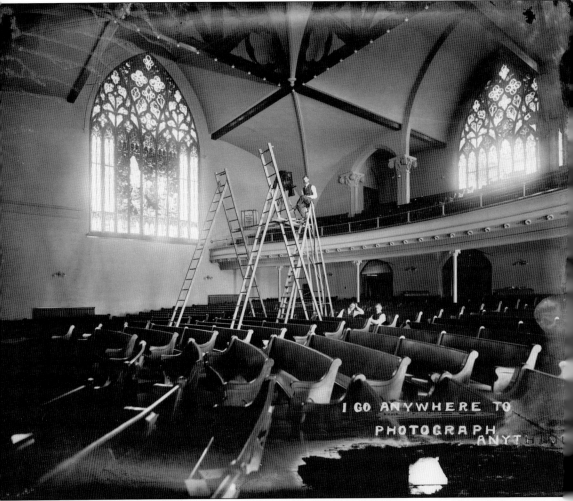

I GO ANYWHERE TO PHOTOGRAPH ANYT[...]

Harry Shipler (1878–1961), who made most of the photographs used in this book, took this 1906 advertising photograph of himself perched on a scaffold inside Salt Lake City's First Presbyterian Church. The Shipler firm was founded in Salt Lake City by Harry's father, James W. Shipler, in 1890. Harry began taking pictures in 1898 and merged his firm with his father's in 1909, becoming the sole proprietor in 1914. The eclectic nature of his interests is indicated by his motto at the bottom of the photograph. (Utah State Historical Society.)

ON THE COVER: Proponents of U.S. entry into the Great War in Europe organized a "Preparedness Movement," which included Preparedness Parades in cities across the country. The *Salt Lake Tribune* reported that 10,000 people marched in the 2-mile-long procession on Main Street, including thousands of children, religious and civic leaders, the National Guard, police, and cadets. (Utah State Historical Society.)

IMAGES
of America
SALT LAKE CITY
1890–1930

Gary Topping, Melissa Coy Ferguson,
and the Utah State Historical Society

ARCADIA
PUBLISHING

Published by Arcadia Publishing
Charleston SC, Chicago IL, Portsmouth NH, San Francisco CA

Printed in the United States of America

Library of Congress Control Number: 2008938759

For all general information contact Arcadia Publishing at:
Telephone 843-853-2070
Fax 843-853-0044
E-mail sales@arcadiapublishing.com
For customer service and orders:
Toll-Free 1-888-313-2665

Visit us on the Internet at www.arcadiapublishing.com

CONTENTS

ACKNOWLEDGMENTS

This book would not have been possible without the generous support of the Utah State Historical Society. Special thanks go to Philip F. Notarianni and Douglas Misner, whose generosity allowed unlimited access to and reproduction of the historical society's extensive photograph collections. In the process of compiling this book, we gained a new appreciation for Salt Lake City. The original brick buildings witnessed a profound transformation of the city, which was once a stop on the way to someplace else but became an urban metropolis. Thank you, Phil and Doug, for allowing us to take the journey.

The majority of the photographs come from the Shipler Collection. However, those photographs that come from other collections are noted in the captions.

INTRODUCTION

During the period covered by this book, Salt Lake City experienced some of the most rapid and profound changes of any city in U.S. history. In its pioneer period, from the beginning of white settlement in 1847 to about 1890, the city had struggled against outside pressures to maintain its identity as a self-sufficient Mormon utopian community, with its theocratic government, agricultural economy, and polygamous society. Upon completion of the transcontinental railroad in 1869, however, its society became increasingly diverse and its economy increasingly linked to the larger nation. With stepped-up pressure from the federal government in the 1880s, polygamy had become increasingly untenable, to the point where it was abandoned at last in 1890. That great capitulation seemed to open the floodgates, and over the next decade, Utah developed a two-party political system, a capitalistic and industrial economy, and a diversified society, and the territory gained statehood in 1896.

As Salt Lake City rushed to catch up with the nation in those tumultuous turn-of-the-century decades, its interior changes were manifested in the exterior appearance of the city. While the completion of the Mormon Temple in 1893 reminded one of the waning theocracy, the construction of First Presbyterian Church (1905) and the Roman Catholic Cathedral of the Madeleine (1909) adjacent to each other on South Temple Street indicated a flourishing new religious diversity. At the same time, monumental new public buildings like the City-County Building on Washington Square (1893) and the state capitol (1915) bore witness to an emerging secular political maturity. And the completion of a long stretch of ornate mansions along South Temple Street, mostly occupied by possessors of wealth gotten by mining or business, symbolized a new economic diversity and prosperity.

That prosperity also manifested itself in such fundamental infrastructural developments as the paving of the city streets as horses and buggies gave way to automobiles and the creation of a public transportation system to support suburban expansion. Suburban development included new recreational facilities to absorb some of the discretionary income generated by the new prosperity: Beck's Hot Springs and the Lagoon amusement park to the north, the Salt Palace south of the city center, and Saltair, the exotic Moorish-style pleasure palace on the eastern shore of Great Salt Lake.

An increasing social diversity was also conspicuous. In addition to the once-humble Irish miners who had struck it rich in the silver mines of the Wasatch and Oquirrh Mountains, a Chinese community emerged in Plum Alley. A Greek community to the south and west of city center became so populous that it was able to erect the magnificent Holy Trinity Cathedral. Social developments also included the formation of labor unions, while the children of victims of mining accidents found a home in St. Ann's Orphanage, erected by the Catholic Church.

The 1890s saw the belated development of a public school system to replace the old ward schools run by the Mormon Church and the sectarian academies sponsored by the Presbyterians and Methodists. The Catholic parochial school system begun in 1875 expanded to include Judge Memorial Catholic High School and All Hallows College, while the Presbyterian Church created Westminster College. Finally, the University of Utah, which in its original incarnation as the University of Deseret had been little more than a glorified high school, became a credible institution of higher learning under the creative leadership of its president, John R. Park.

One

URBAN DEVELOPMENT

An industrialized, capitalist economy and a swelling population conveyed about by mechanized vehicles required fundamental infrastructure developments. Trash disposal became a pressing problem, as did the need for development of an effective city sewer system. The city's unpaved streets, which had been a dusty nuisance in the summer and a muddy menace in the winter, could nevertheless be navigated during the earlier years by animal-drawn, high-wheeled wagons and carriages. With the advent of the automobile and the bicycle, though, the wintry mire could be a traffic stopper. An ongoing theme, therefore, during the period of this book was the installation of paved streets and sidewalks.

The photographs in this chapter show a gradual change from animal-drawn transportation to various types of automobiles. That transition required development of more infrastructural elements than just paved streets, for cars were dependent upon gasoline stations for fuel and garages for repair. And the freedom of the automobile tempted intrepid travelers to plan long-distance trips bundled up in overcoats behind bug screens.

For long-distance travel, though, and as a freight medium, the railroad still reigned supreme. Several railroads, like the Union Pacific, the D&RG, and the Oregon Short Line, extended their track mileage in Utah during this period and built monumental passenger depots that celebrated the supremacy of the train. Rail transport was also practical for urban and interurban travel, particularly in those transitional days while streets and roads were being paved, and Trolley Square was an important hub for commuter rail traffic.

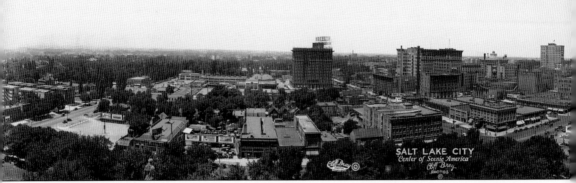

Joseph Smith, founder of the Church of Jesus Christ of Latter-day Saints (commonly known as the Mormon Church), designed the grid pattern that characterizes Salt Lake City's unique street system. North, South, East, and West Temple Streets border the LDS temple, with street numbers increasing concentrically out from the epicenter. (In other words, the further south, the higher the numbers: 100 South, 200 South, 300 South, and so on.) Salt Lakers tend to drop the "hundred" when speaking of the streets, preferring to call them First South or Second South, for example. The emerging urban maturity of Salt Lake City is apparent in this 1929 panoramic view from the roof of the City-County Building on Fourth South Street. Paved streets, automobile traffic,

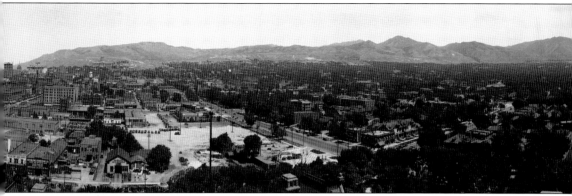

and even a few modest skyscrapers give the city a typical American appearance. The state capitol in the distance and the City-County Building indicate a corresponding political maturity. The immense Hotel Utah and Newhouse Hotel indicate the city's importance as a hub of business and tourism. Exchange Place, where the Utah stock market is situated, indicates an emerging capitalist economy, as does the Walker Bank building. The Salt Lake Temple and Cathedral of the Madeleine, headquarters of the Mormon and Catholic Churches respectively, indicate the city's emerging religious diversity.

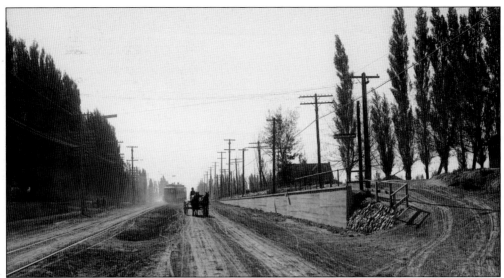

The old and the new Salt Lake City are conspicuously on display in this October 1910 view of South State Street in the developing suburbs. One can easily imagine what that unpaved street would look like in midwinter, when a well-used roadway could become a knee-deep mire. Thus that trolley car from the Utah Light and Railway Company provides a much more attractive alternative for the commuter than the horse and buggy.

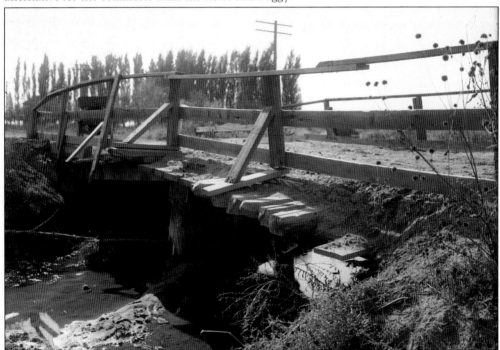

State Street, which spans the entire length of Salt Lake Valley from Point of the Mountain to the capitol, ran mostly through farmland at the time of this 1910 photograph. This ramshackle bridge hardly seems safe even for horses and wagons, let alone the automobile at its far end. Expansion of the city's population and the advent of motorized vehicles necessitated the replacement of such structures.

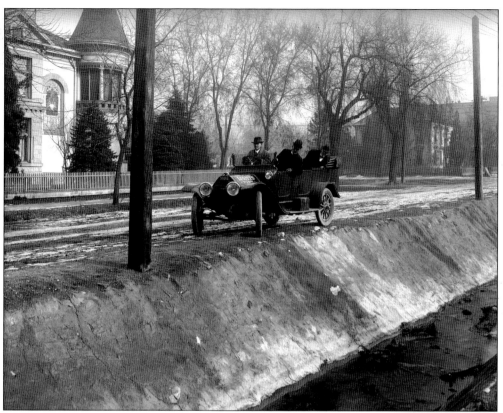

This unidentified Salt Lake City street illustrates some of the ways in which early automobile owners found the streets inhospitable. Not only was there risk of a precipitous drop-off into the irrigation ditch running down the middle of the street, but the unpaved street itself offered the additional inconvenience of mud splashing on car and driver and even the hazard of becoming completely stuck.

In this 1910 photograph, a woman approaches a boardwalk in front of a construction site at the Kearns Building. Although temporary, this primitive sidewalk on Main Street would have been a welcome piece of infrastructure, protecting the woman from getting dust, mud, or horse droppings on her shoes. By the 1910s, ladies' dresses had shortened to just above the ankle—no doubt a welcome fashion change in the dusty streets of the West.

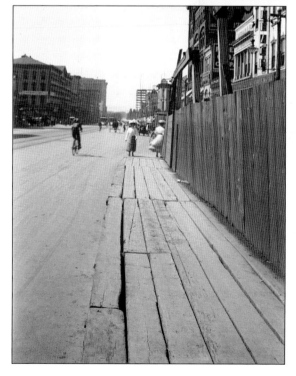

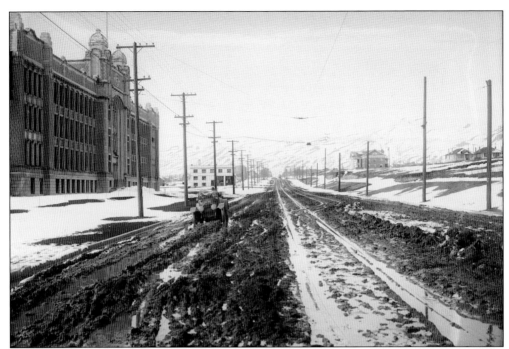

Although the winter mud of Salt Lake City's unpaved streets was an inconvenience to pedestrians and drivers of horse-drawn vehicles, it was a serious hazard to automobilists. This car is completely stuck in the mud of 1300 East just north of the 900 South intersection in front of East High School. Paving the streets required the creation of a new public utilities infrastructure and a higher tax burden.

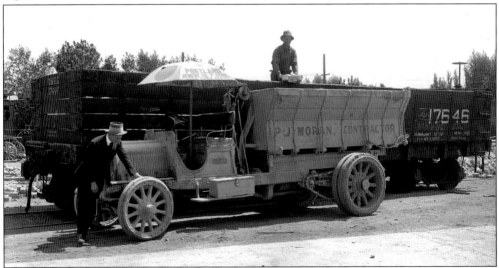

The unknown and unsung hero of Salt Lake City's transportation revolution from horse-drawn to motorized conveyances was Patrick J. Moran, for it was he who paved the city's streets. Utilizing his cement plant in Parley's Canyon, Moran replaced the muddy quagmires those streets could become in the winter with concrete pavement. Moran was also the contractor who built the Lucin Cutoff, a railroad trestle across the northern part of Great Salt Lake, eliminating many miles of detour around the lake.

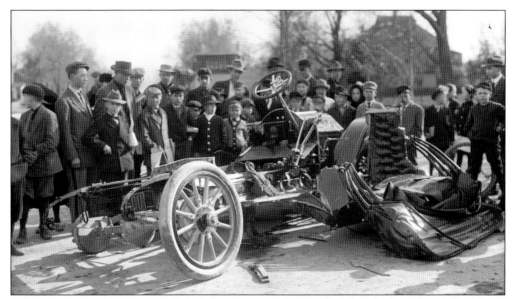

Salt Lake City's maturation included the advent of the automobile, which included the advent of the automobile accident, such as this 1911 wreck at Fifth East and South Temple Streets. Controlling an automobile involved a different set of skills from controlling a horse. That, plus the absence of traffic lights such as the one that nowadays controls that intersection, may have accounted for this mishap.

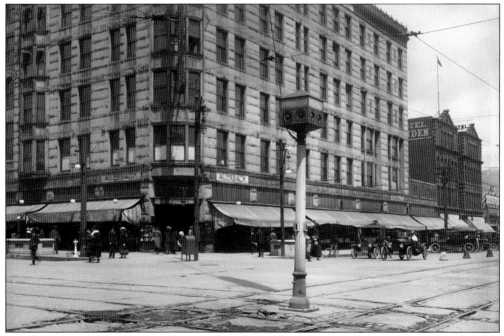

Salt Lake City's burgeoning population in the early 20th century and the increased speed of its automobile traffic made the city streets increasingly dangerous places. At first, uniformed police officers were stationed at some of the busiest intersections to direct traffic, but that came to appear as a waste of human resources. Eventually, an inventor named Lester F. Wire devised an electric semaphore system such as this one at the intersection of State Street and 300 South in 1918.

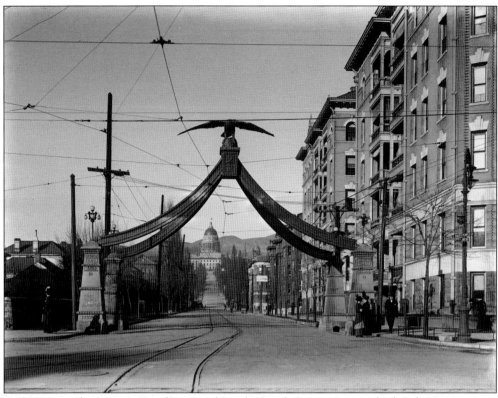

Eagle Gate, at the intersection of State and South Temple Streets, is one of Salt Lake City's unique landmarks. Originally erected to mark the entrance to Brigham Young's City Creek Canyon property, Eagle Gate in this 1914 photograph frames a view of some very modern developments, showing the city moving away from its agricultural roots: electric streetcar power lines stretch overhead, while the new state capitol is seen beneath the gate's span, and high-rise apartment buildings line the street on the right.

It would be hard to find a photograph that depicts more vividly the transition of Salt Lake City from pioneer village to modern city than this 1920 view of upper State Street. Visible in the photograph are, from left to right, the Gilded Age architecture of the Salt Lake Public Library (later the Hansen Planetarium), the modern high-rise Belvedere Apartments, and the social hall erected by Brigham Young to provide a gathering place for social events.

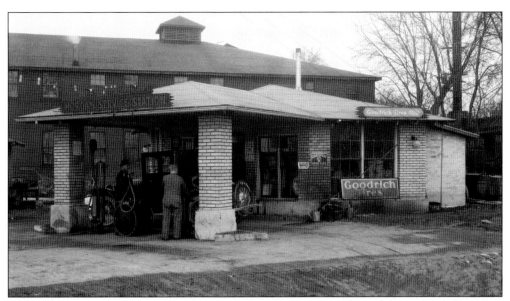

Although the year of this photograph is 1922, the still-primitive nature of the automobiles in Salt Lake City and the gas stations and garages that kept them on the streets is apparent. The Morgan Service Station at 2189 Highland Drive in Sugarhouse, which would have been on the southern outskirts of the city at that time, has only one gas pump to serve one car at a time.

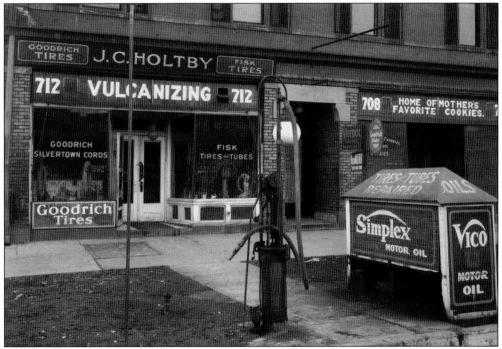

One can hardly imagine a simpler automotive service station than the J. C. Holtby station at 712 South State Street in 1922, a time in which cars were becoming quite common. Consisting only of a single pump powered by a hand-operated crank, it offered the single convenience that motorists did not even have to leave the street to fill their tanks; all they needed to do was pull over to the curb. Within a short period of time, drivers would come to expect much more than this.

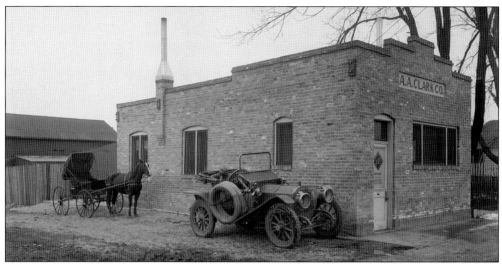

The A. A. Clark Company, whose office is depicted here, was an engineering contracting firm on 400 West. The horse and buggy parked behind the automobile was no doubt a common sight in 1913, when this photograph was taken, symbolizing the transition from a traditional mode of transportation to a modern one. Each had their advantages and disadvantages, but a horse will always start on a cold morning!

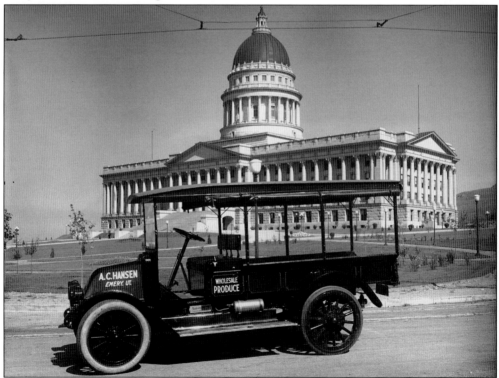

Few images depict the modernization of Utah in the early 20th century than this 1918 photograph of a motorized produce wagon in front of the new (1915) state capitol building. Not only were capitalism, technology, and industrialism transforming the urban economy, but they were even reaching the rural parts of the state (Emery, Utah, is in the central part of the state).

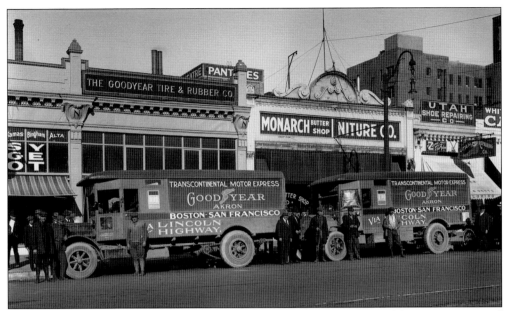

In 1913, a group of automobile and tire dealers began a movement to build a transcontinental highway, part of which would cross Utah. Although there were already, of course, transcontinental railroad lines, other vehicular traffic was confined to local routes. These two trucks parked on State Street in 1918 are obviously advertising the new Lincoln Highway, which passed from Salt Lake City to Wendover roughly along the route of modern Interstate 80.

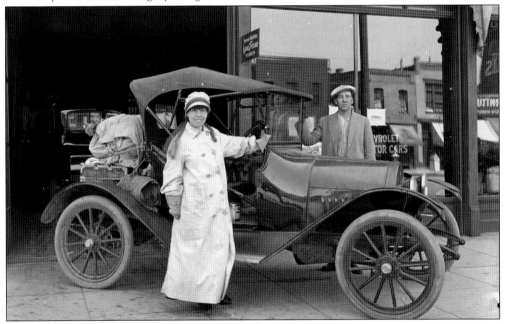

While the automobile opened up the possibility of long-range travel, as this couple is demonstrating, early car models often provided little more protection from the elements than a covered wagon had done in the pioneer era. With its higher speed, in fact, exposure was even greater than in the age of horse-drawn conveyances. This couple—the woman, at least—has had to provide their own shelter.

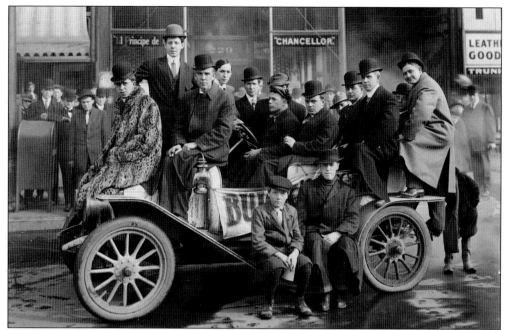

Randall-Dodd Auto Company advertised this Buick Model 10, shown in 1910, as "the talk of the town." The dealer took prospective buyers to the top of Ensign Peak, a large hill overlooking the Salt Lake Valley. The full-page advertisement that appeared in the *Salt Lake Herald* asks "Hard climb? Yes—but the Buick is made for hard climbs. Rocky road? Well, we should say—but the Buick never balked yet—even on the shaggy sides of 'old Ensign.'"

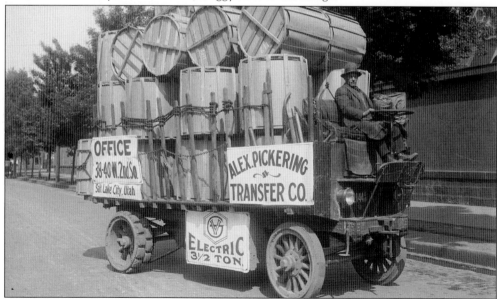

This electric truck used by the Alex Pickering Transfer Company would once again be cutting-edge technology during the energy crisis that has afflicted the country since the 1970s. Few people remember how various power sources—steam, electricity, diesel, and gasoline—competed for dominance during the early years of automotive development. This photograph was made in 1918.

Though popular, efficient, and enjoyable, bicycle transportation in the days before paving could prove to be a rough ride. John Held Jr. reminisced that his father, "pedaling gayly homeward atop his high wheel . . . turned a sharp curve into the darkness and ran smack bang into the watering trough that some prankster had pulled across the sidewalk." His father flew over his handlebars and "carried the scars of the extracted gravel through his life." (Classified Photograph Collection.)

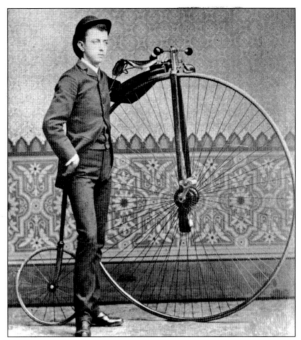

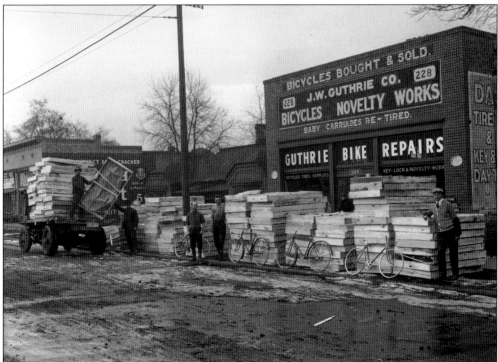

The J. W. Guthrie Company has sold bicycles at its 228 East 200 South location at least since this 1917 photograph. Bicycles may not have been the ideal mode of transportation on Salt Lake City's muddy winter streets, but enthusiasts bought them by the hundreds anyway. Recreational riding and professional racing were two immensely popular forms of bicycling. This new shipment at Guthrie's indicates a thriving business.

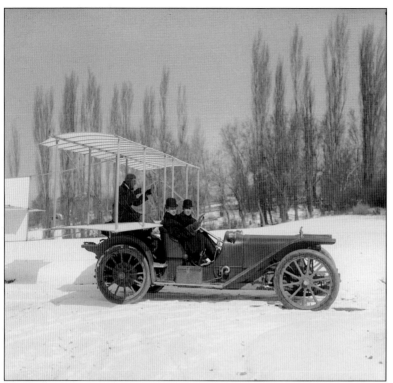

The Machine Age comes to Salt Lake City. Both the airplane and the automobile were new inventions at the time of this 1910 photograph. Unlike the Wright brothers' airplane, this glider is not motorized, and the three men are apparently attempting to borrow the power of the automobile to launch their aircraft.

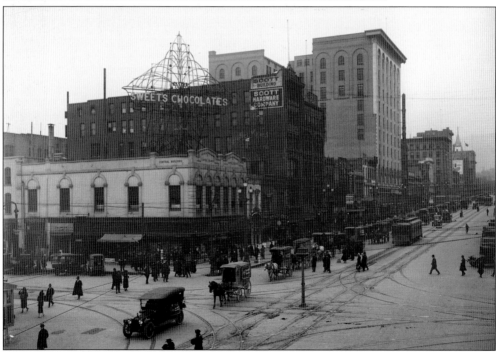

By the end of World War I, the transportation revolution was well underway in Salt Lake City, as shown in this 1919 view of the intersection of 200 South and Main Street. In addition to the electric trolley car, vehicles appear to be in a transition to motorized from horse-drawn conveyances.

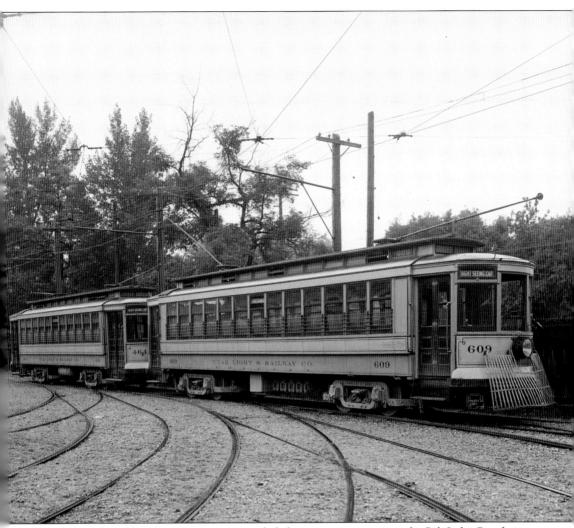

The Utah Light and Railway Company provided electric streetcar service for Salt Lake City from its carbarn, in front of which these two cars are parked. Now known as Trolley Square, it is a major shopping mall. Not only did this service make suburban living possible, it also provided a convenient way for tourists to see the city. Note the "Sight Seeing Car" label on the one in front.

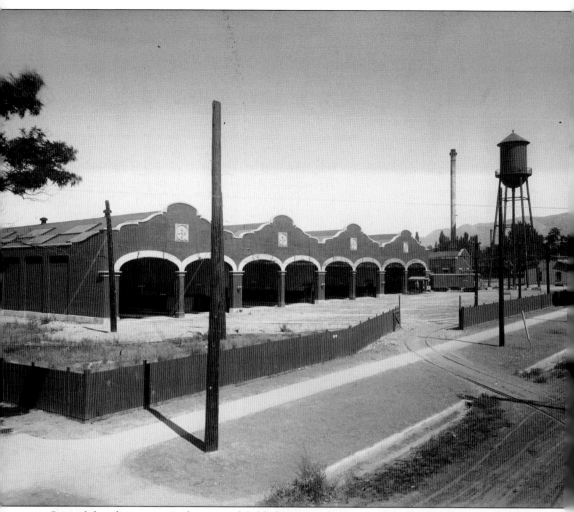

One of the characteristic features of Gilded Age America was the development of suburbs as the nation's cities became industrial rather than commercial centers. These suburbs were made possible by the development of electric streetcar lines to transport people from workplace to dwelling place. Various Salt Lake City streetcar lines merged in 1901 under the name Utah Light and Railway Company, and even more lines were added in 1914 in a merger creating the Utah Light and Traction Company. By 1918, the company had over 146 miles of tracks operating out of this station at Trolley Square, shown under construction in 1910.

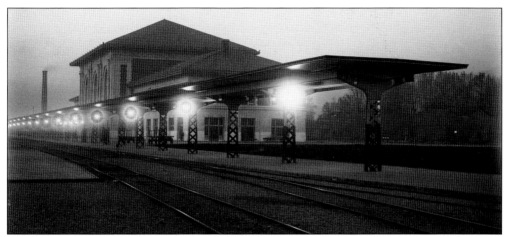

The Denver and Rio Grande Western Railroad (D&RG), a narrow-gauge line, reached Salt Lake City in March 1883. While the narrow-gauge was a more practical way of transporting ore from mines in the steep Rocky Mountains, it was less efficient for transporting cargo over flatter terrain, so the line was converted to standard-gauge when it began competing with lines like the Oregon Short Line Railroad for the carrying trade through rural Utah. This moody photograph from 1911 shows the newly constructed D&RG depot in Salt Lake City.

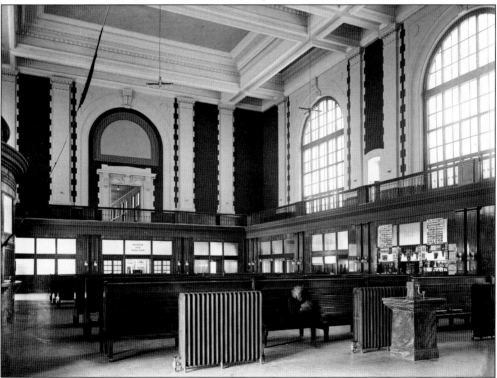

One of Salt Lake City's architectural monuments, this view of the interior of the Denver and Rio Grande railroad station in 1910 exemplifies the grand scale of design lavished on such structures during the late 19th and early 20th centuries. This view shows the ticket office on the left, and the south end of the building, which today houses the Antiquities and Preservation sections of the Utah State Historical Society, with the Research Center on the ground floor.

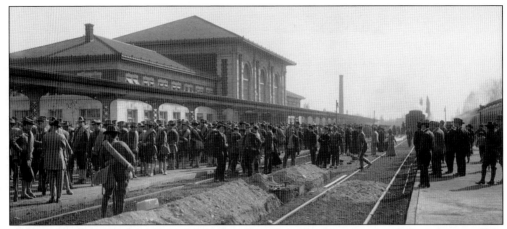

This trackside view of the Denver and Rio Grande railroad station in 1911 appears to show construction still underway. It also shows, in the presence of a large contingent of National Guard soldiers, that the railroad had military as well as commercial utility. During the Civil War, in which Union soldiers had demonstrated an advantage in mobility over the less mechanized Confederate forces, the desirability of the railroad, even in transporting troops to training sites, as it is doing here, had become apparent.

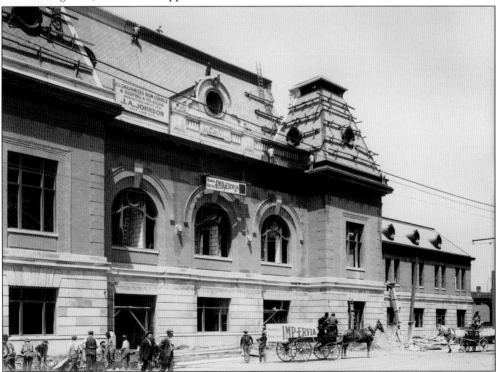

Railroading was big business during the late 19th and early 20th centuries, in Utah and throughout the West. Trains were an immense improvement over animal-drawn vehicles for passenger transportation and were really the only practical way to convey agricultural produce to market and manufactured goods to the West. Thus it was that railroad station architecture, exemplified in the construction photograph of the Oregon Short Line Railroad station in Salt Lake City, reflected the economic and social importance of the railroad in its monumental style.

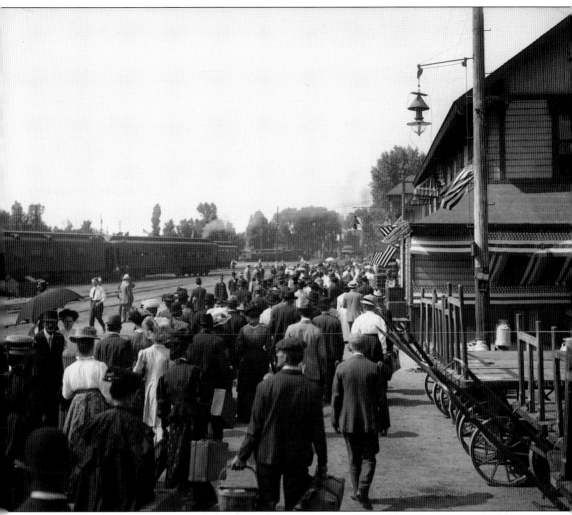

Completion of the transcontinental railroad with the joining of the Union Pacific and Central Pacific lines in Utah on May 10, 1869, was only the first step toward providing railroad service to residents of the West's wide-open spaces. Even more important was the construction of spur lines to rural areas, often financed by small independent companies or subsidiaries of the national railroads. One of the most important of those was the Oregon Short Line Railroad, throughout most of its history a subsidiary of Union Pacific, operating from this station on 400 West and South Temple Street in Salt Lake City.

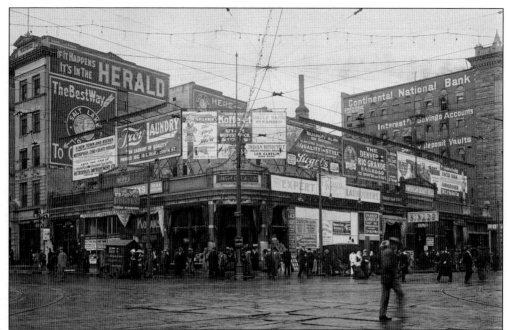

Not all aspects of Salt Lake City's urban maturation in the early 20th century were beautiful. This view of the Smith's Drug Store on the corner of 200 South and Main Street shows a hideous array of overhead electrical lines and billboard advertisements, some of them painted right on the sides of buildings. Eventually the Walker Bank building replaced the drugstore, but controlling the proliferation of signs awaited more enlightened city planners of a later generation.

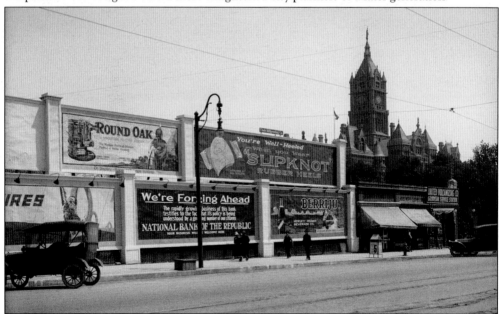

Along with a capitalist, industrialized economy came the necessity of advertising. This block along State Street north of 400 South features not one but two tiers of billboards advertising various Salt Lake City businesses. The unsightliness of the advertisements is rendered all the more garish by contrast with the monumental architecture of the City-County Building in the distance.

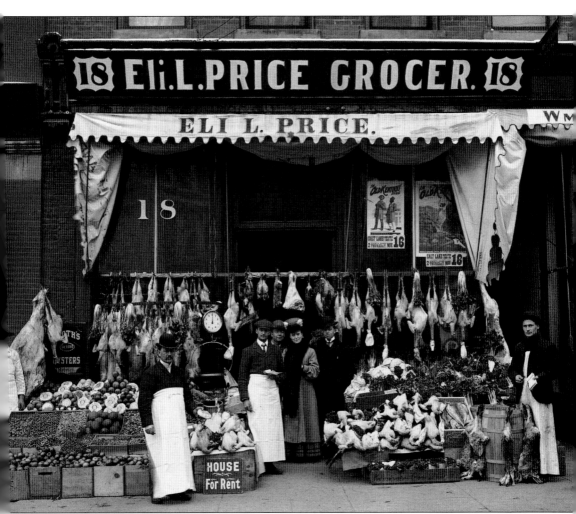

Growing cities accommodated their inhabitants by developing separate work and living spaces. People lived and shopped near their place of employment until the widespread availability of the automobile pushed living spaces to the outskirts of the city. This photograph of a downtown grocer features a sign in the foreground advertising a house for rent, which may refer to the living space above the store.

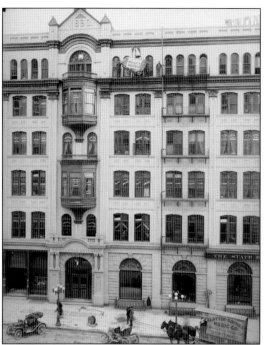

For all the depictions of piano moving in various 20th-century children's cartoons, it was truly a dangerous and tricky task. Unlike moving an upright piano, moving a grand piano required professional movers. This photograph shows a piano taken to the top floor of the Templeton Building in downtown Salt Lake City.

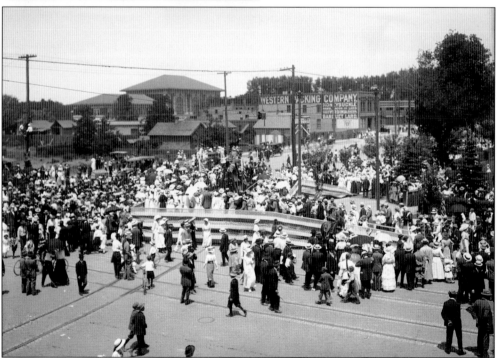

In 1915, the Liberty Bell made a cross-country trip, stopping in big cities for local residents to take a gander at the historic symbol of the United States. This photograph provides a view of the western portion of downtown. The large crowd is gathered around the Armour and Company meat store. The Rio Grande depot is in the background. The open walking space is now filled with businesses and coffee shops.

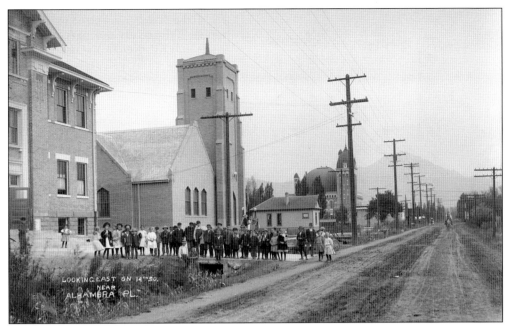

Salt Lake City's growing suburbia is well illustrated in this 1910 street scene at Alhambra Place (now 3300 South, between State and Main Streets). Depicted from left to right are the Blaine School, the Miller LDS Ward, an unidentified residence, and the LDS Granite State Tabernacle. People were still commuting into the city for work, but residences, churches, and schools were now growing up in outlying areas, indicating an urban maturity not previously seen in Utah.

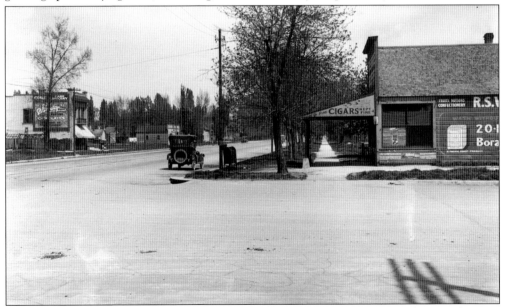

The intersection of 800 South and Main Street—a location right downtown today—in this 1921 photograph shows that many downtown sites were still awaiting the urban development that other districts were experiencing. The widely spaced buildings, for one thing, betray the urban design of the pioneer period, when garden plots were part of residential lots and businesses were few and far between.

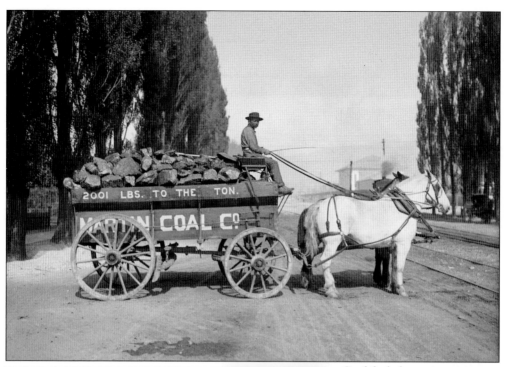

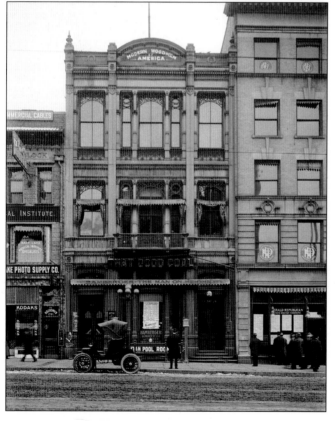

Coal fueled growing cities across the United States, providing heat in the winter and power for machinery. For large cities such as Pittsburgh and New York City, burning coal brought inordinate amounts of soot. Salt Lake City had a much smaller population, so coal had less of an impact on air quality than it had in larger cities. Still, coal mining was dangerous work in all parts of the country, and Bamberger Coal, whose offices on Main Street are pictured to the left, shipped its coal from the mines in the southeastern part of the state. Urban coal use is an example of the journey that raw materials took from rural areas to support urban life.

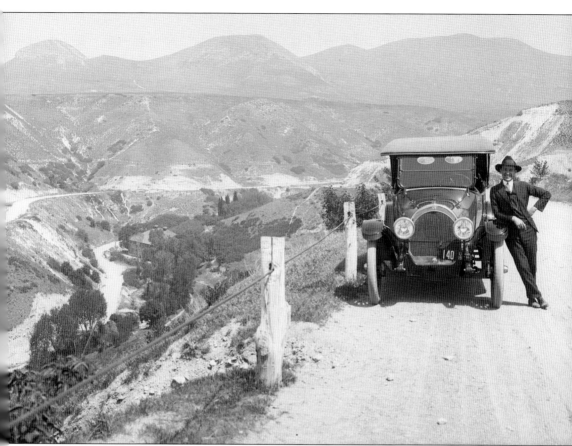

The dapper driver of this Oldsmobile has stopped to enjoy the view over City Creek Canyon and the Wasatch Mountains in 1919. Drivers on unpaved Eleventh Avenue were protected from a long fall into the canyon only by this shaky cable fence. As the 20th century advanced, the lone building visible on the canyon floor would be joined by dozens of expensive residences in the foothills.

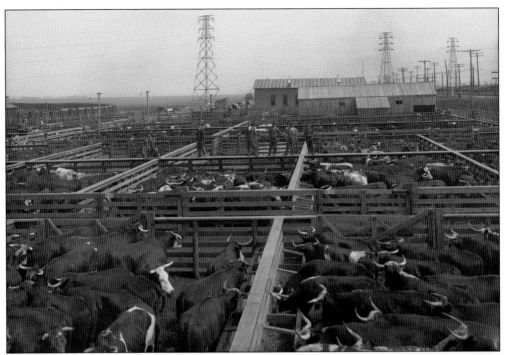

As in other cities, Salt Lake City's growth meant that the rural sector provided raw goods for the city, and the city was the site of consumption. The city became a revolving door that received raw materials and shipped its waste back to the rural sector. The Salt Lake Union Stockyards, photographed in 1917, provided cattle to a nearby slaughterhouse, whereupon the beef was shipped to the city in train cars refrigerated by ice.

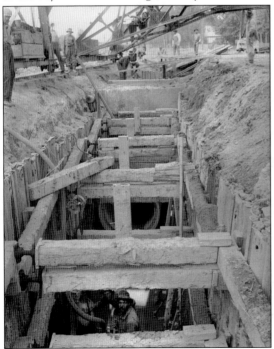

The population increase strained the city's capacity for handling wastewater. The first sewer line was laid in Salt Lake City's business district in 1889, draining sewage into the Jordan River on the western outskirts of the city. By 1911, a 5-mile canal drained sewage into the Great Salt Lake instead. This photograph depicts sewer line construction at 900 South and 700 West. Note the two workers in the foreground.

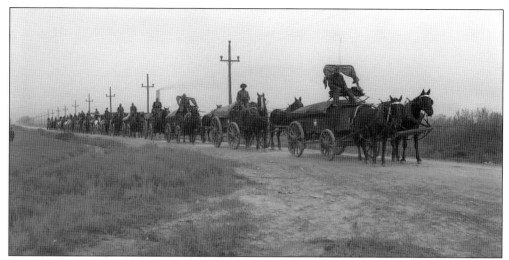

Salt Lake City's population skyrocketed between 1890 and 1920. Like other major cities across the country, Salt Lake City struggled with poor sanitation. The city rarely collected the garbage that piled up outside people's homes, providing a breeding ground for flies and rats. The Civic Improvement League, founded in 1906, oversaw and regulated garbage collection. Horse-drawn carriages collected garbage from the city and relocated it outside of the city limits. The league also offered to pay children 10¢ for each dead rat and 10¢ for 100 flies. Because of the health risks, the rat and fly ordinances did not last long.

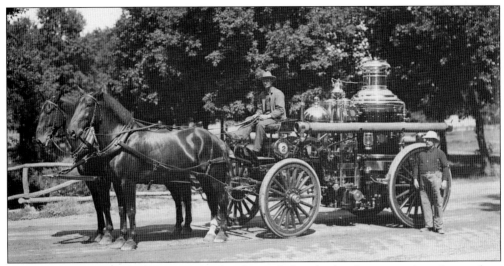

Public services grew with the city, and technology aided in the fire department's professionalism and effectiveness. Volunteers fought fires in Salt Lake City, and "at the call of fire armed themselves with the domestic bucket" until 1856, according to the *Souvenir History of the Salt Lake Fire Department*. In 1883, a steamer exploded on Main Street, sending a wake of fire across the block and causing $20,000 worth of damage in plate glass alone. The 1883 fire was a harsh lesson that a volunteer firefighting force no longer met the city's needs. In the 1890s, paid firefighters responded to an alarm wired through the telegraph system. When the photograph above was taken in 1905, the department used horse-drawn carriages for fire disposal. The automobiles in the 1912 photograph below revolutionized firefighters' response time.

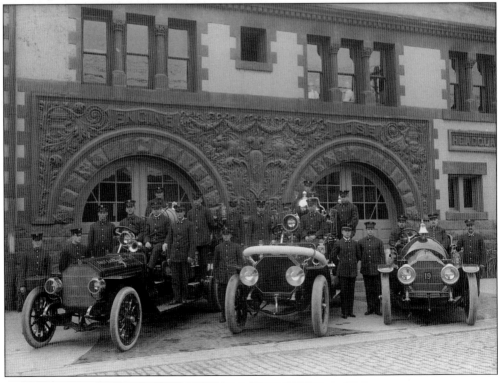

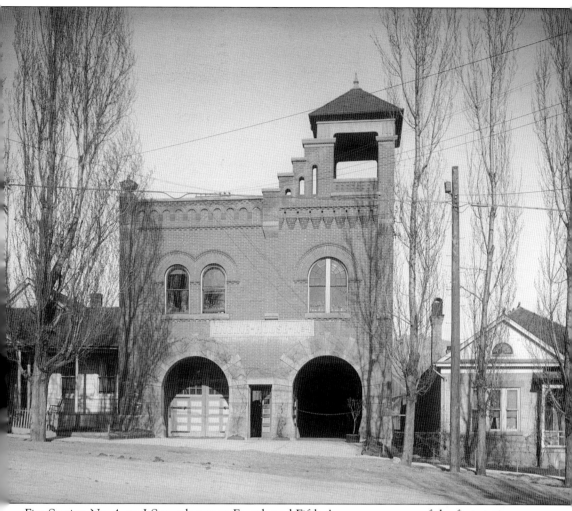

Fire Station No. 4, on I Street between Fourth and Fifth Avenues, was one of the first stations housing Salt Lake City's professional, motorized units. By 1909, when this photograph was taken, there were approximately 10 of these stations in various parts of the city. Salt Lake City's burgeoning population and coal-powered factories raised the risk of fires and made the expansion of fire protection services necessary.

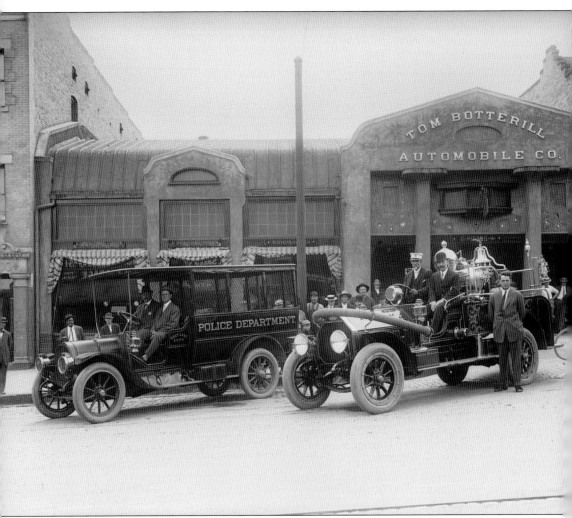

Public safety and security in the early 20th century required that horse-drawn equipment give way to motorized vehicles, just as volunteer fire crews had given way to professional firefighters in 1883. In this 1911 photograph, the police and fire departments show off their new vehicles in front of dealer Tom Botterill's store. This particular fire truck was later destroyed in a tragic crash while on a call.

Two

ECONOMIC AND SOCIAL DEVELOPMENT

Although the Utah economy remained heavily agricultural during the period covered by this book, the economy of Salt Lake City itself became increasingly diversified. As wealth from the silver mines, primarily in the Wasatch Mountains, began to flow into the city, a conspicuous disparity in economic and social classes developed. While lavish mansions continued to be built along South Temple Street, an underclass of common laborers and homeless persons appeared. The Alta Club, a luxurious rendezvous for wealthy local men, joined lavish hotels like the Hotel Utah and the Newhouse Hotel, which catered to visiting business people.

At the same time, the work force became diversified. Women, who had been generally confined to domestic roles, now began finding employment as telephone operators, department store clerks, nurses, and teachers. The work force also included members of ethnic groups like Greeks, Italians, Japanese, and Chinese.

In the general prosperity of the day, consumers found a proliferation of goods on which to spend their income. Department stores like Auerbach's offered tempting displays of their wares in street-front windows, while Salt Lake City streetscapes became clogged with billboards and advertisements painted on the sides of buildings.

Finally, as in any capitalistic economy, labor-management conflicts began spilling over into sometimes violent and disruptive strikes. Unionization became common in a variety of industries, including even b newsboys and bootblacks.

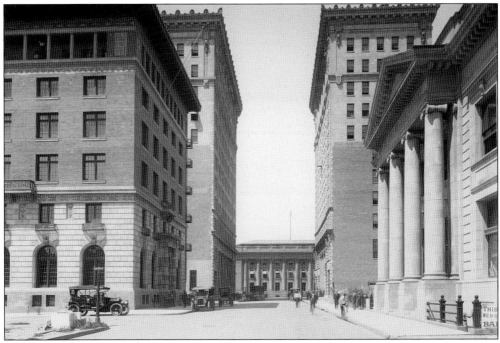

Exchange Place, Salt Lake City's financial district between State and Main Streets and Third and Fourth South, was regarded as the non-Mormon center of the city, counterbalancing Temple Square at the other end of State Street. Although the Salt Lake Mining and Stock Exchange was a far cry from Wall Street, it symbolized the developing capitalism in the Utah economy.

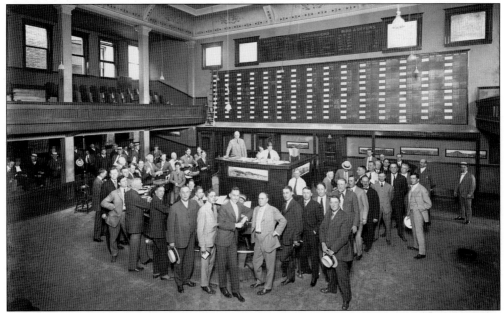

This is the interior of the Salt Lake Mining and Stock Exchange at Exchange Place off South State Street, showing the main trading room in 1916. It was mining, primarily of silver, in the mountains near Salt Lake City beginning in the 1870s that spurred the growth of a capitalistic economy in Utah, which was grafted onto the largely agricultural economy of the pioneer era.

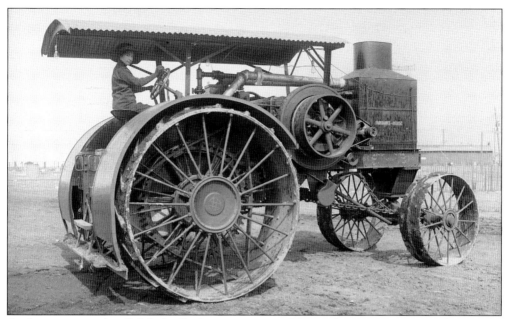

At the same time that Salt Lake City's economy was adding industry to commerce, the growing population of laborers required a similar agricultural industrialization to feed them. The huge tractor displayed at the state fairgrounds in this 1912 photograph was made by Fairbanks Morse. The photograph may have been used in advertising to show that the behemoth was drivable even by a woman.

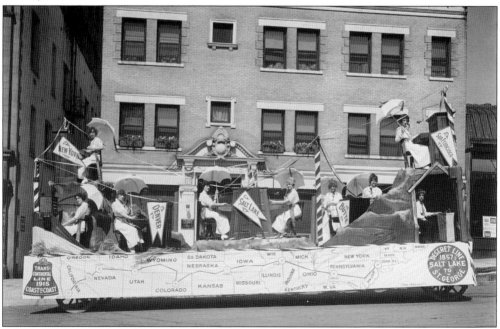

July 24, the anniversary of the arrival of the first Mormon pioneers in Salt Lake Valley in 1847, has always been an even bigger holiday than Independence Day. This float in the 1915 "Days of '47" parade, sponsored by Mountain States Telephone and Telegraph Company, commemorates the completion of the first transcontinental telephone line that year.

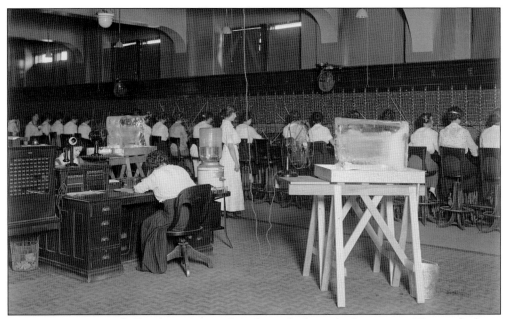

Amenities sometimes had to be improvised in the early days of urbanization. These telephone operators at the Mountain States Telephone and Telegraph Company offices at 54-56 South State Street are keeping cool on a hot August afternoon in 1915 by means of electric fans blowing air across blocks of ice. Note that the racks holding the ice are slanted to catch the melting water. Although the fans do not seem very powerful, this system could have worked rather well.

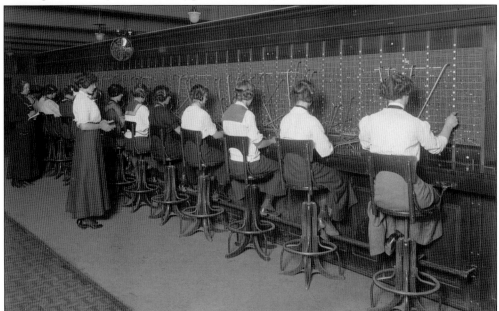

Male operators dominated telegraphy in 1910, but as the telephone industry grew, female operators overwhelmingly dominated the industry. When given a choice, women preferred telephone or office work, because they were spared the long hours and dangers of the factory. Like other women across the nation, Salt Lake City telephone operators and office workers were usually young, white, and single.

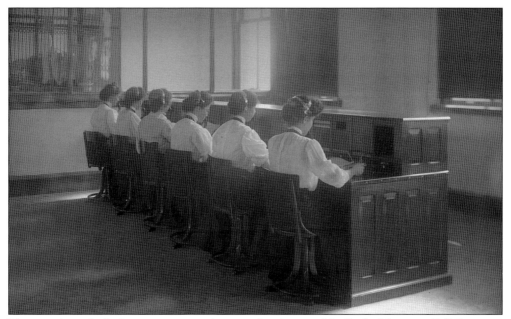

These uniformed telephone operators at the central exchange of the Rocky Mountain Bell Company at 56 South State Street in 1907 indicate the importance of the human element in early electronic communication. They also indicate an expanding role for women in the workplace instead of only domestic functions. Primitive as these early telephone systems were, it is easy to become nostalgic for them whenever we call a help line and find ourselves talking to a computer.

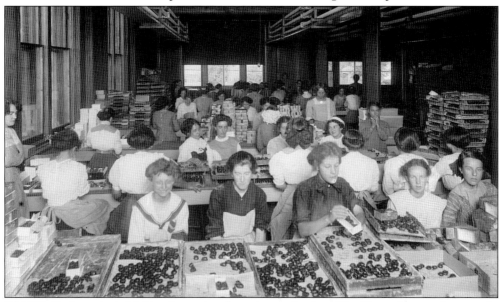

By 1916, Utah ranked third in the nation for sugar production. The 21 candy manufacturers in the state were by-products of Utah's sugar beet industry. The seasonal nature of candy making provided temporary, part-time work for married women looking for extra money without committing to the dual nature of becoming a working mother. This photograph was taken in 1911 at the Sweet Candy Company, which continues to sell products such as orange sticks, saltwater taffy, and cinnamon bears worldwide.

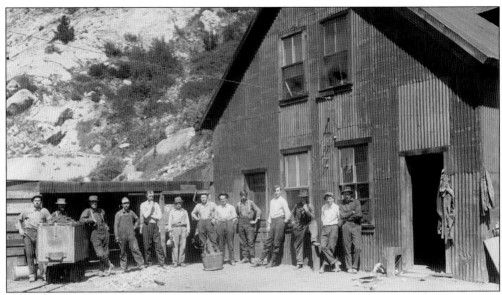

Most of the money that fed Salt Lake City's economic growth and urban development around the beginning of the 20th century came from the silver mines in the Wasatch Mountains that tower over the city to the east. The miners in this 1915 photograph are working the Alta Consolidated Mine in Little Cottonwood Canyon.

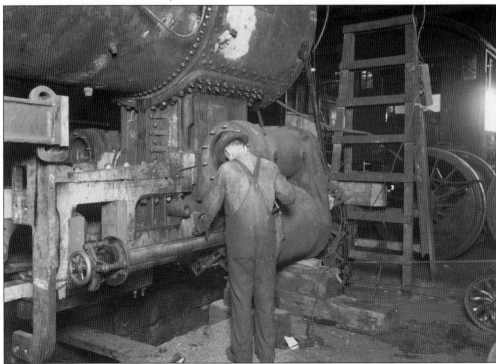

Industrialization at the beginning of the 20th century created a wide social gap that polarized the educated and uneducated in the struggle between capital and labor. Skilled and unskilled labor could literally mean life or death. This image shows a laborer at the Denver and Rio Grande shop in 1917, working on an engine where a man had been killed.

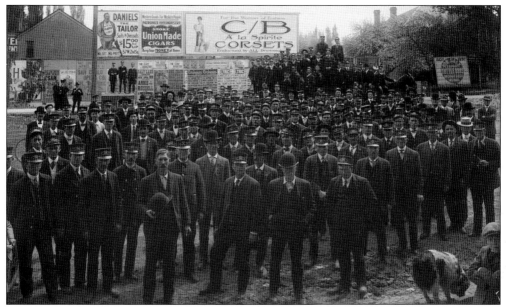

Throughout April 1907, Utah Light and Railway Company's unionized streetcar, electric, and telephone workers demanded better hours and better pay. After several attempts at arbitration, the union decided to strike on April 28. Over 400 streetcar drivers took to the streets. Strikers cut trolley ropes and threw rotten eggs and fruit at strikebreakers. The *Salt Lake Herald* reported two arrests, one of which was a deputy sheriff who punched a boy while wearing brass knuckles and brandished a revolver at the crowd. The strike crippled the city. City businesses and residences did not have power or transportation for over 24 hours. Avoiding a prolonged strike, Utah Light and Railway Company met strikers' demands by increasing wages from 25¢ an hour to 30¢ an hour and shortening the 14-hour workday to 12 hours.

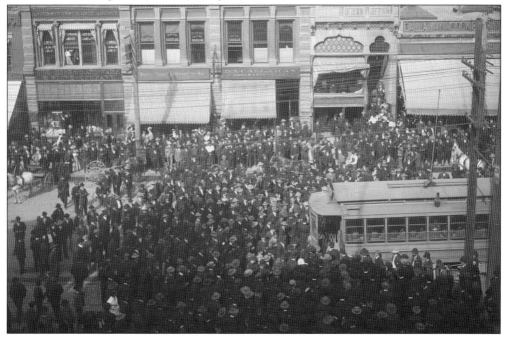

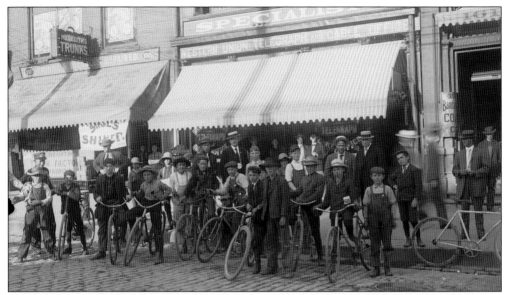

Messenger services offered employment opportunities for boys. In 1906, fifty messenger boys worked in Salt Lake, half of whom were under 16 years of age. They were compensated with a percentage of sales profits, though their employers often cheated them out of their wages. On August 8, 1907, Western Union operators struck across the country, and the messenger boys seized the opportunity to demand better pay.

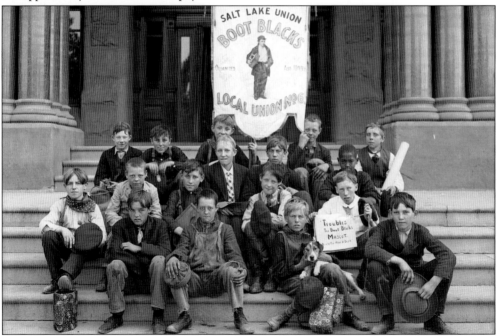

Between 1870 and 1900, less than 4 percent of children in the Rocky Mountain Region were employed. However, over 10 percent of working boys were the main breadwinners for their families. The Salt Lake Union Boot Blacks are posing on the steps of the City-County Building during the 1907 Labor Day parade. The sign reads: "Troubles, the Boot Blacks Mascot. He's better than a scab."

In this 1916 photograph, Suzanne Bransford Holmes is posing in one of her many fashionable dresses. Holmes, known in the West as the "Silver Queen," acquired her fortune from silver mines in Park City. Her life was filled with drama, including an estranged daughter, familial struggles over money in her later life, and a total of four husbands—all of which provided plenty of fuel for newspaper sales.

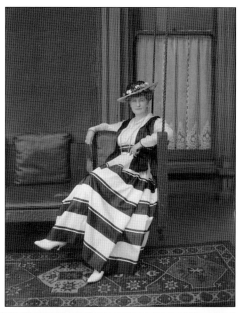

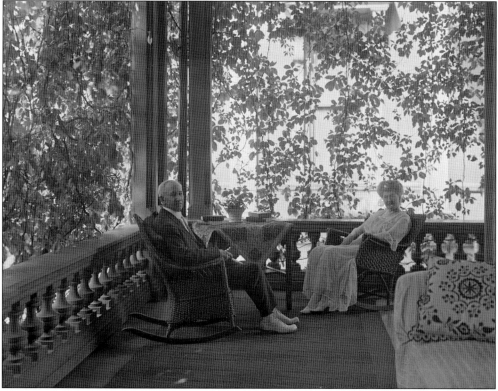

Suzanne married her second husband, Col. Edwin Holmes, in 1899, when she was 40 and he was 56. Holmes was quite wealthy himself, and he purchased the Gardo House for Suzanne's birthday. The couple threw lavish parties at the house, which included an art gallery and five pianos, clear symbols of the Holmeses' immense wealth and status. Here the couple relaxes on the porch in 1916.

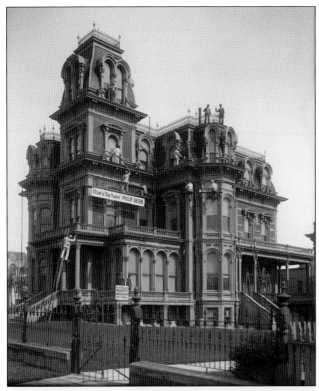

Brigham Young had the Mormon church build the Gardo House (left) to host visitors, but with Young's alleged favorite wife Amelia as hostess, the home gained the nickname "Amelia's Palace." The Holmeses purchased this remarkable mansion in 1901. Originally, the exterior was painted beige with white trim, but Suzanne repainted the home in the Victorian style— deep red with white and blue accents on the window frames. Red, white, and blue stripes decorated the awnings. The Gardo House was not her only property; below, Suzanne holds one of her many elegant parties, though this 1916 lawn party is taking place at Oakwood, her East Mill Creek estate.

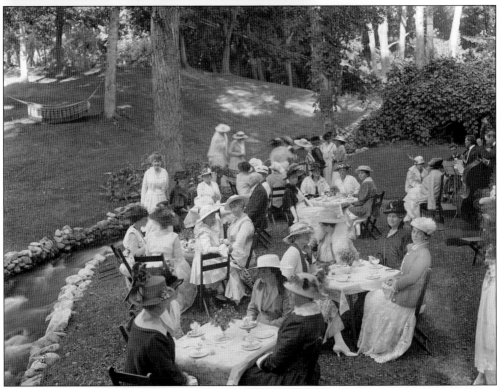

These children were photographed on August 13, 1920, behind the Thompson mansion at 529 East South Temple Street. A Salt Lake City native born in 1850, Ezra Thompson made his fortune through Park City's mining industry. Thompson served as mayor of Salt Lake City for three terms at the turn of the century. The children pictured are possibly Thompson's grandchildren. Note the children's fashions and hairstyles. Anyone who has tried to curl a three-year-old's hair can appreciate those perfect ringlets!

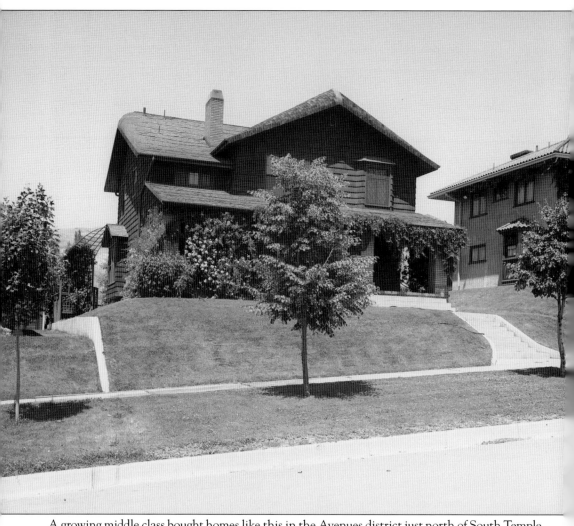

A growing middle class bought homes like this in the Avenues district just north of South Temple Street. This home belonged to Murray Sullivan, a prominent international and local civil engineer who moved to Utah in 1906 after joining the Oregon Short Line. Professional opportunities increasingly brought educated non-natives to the region, which threatened Mormon political and economic hegemony.

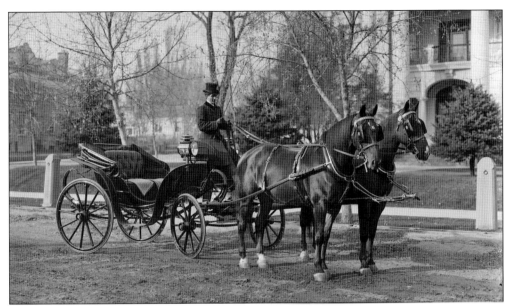

One of the signs of Salt Lake City's urban maturation was the emergence of an upper class, as seen in this photograph of a carriage and driver in front of the David Keith mansion on South Temple Street. Keith (1847–1918) and his partner, Thomas Kearns, made immense fortunes from the Silver King mine in Park City, Utah, and built mansions on adjacent blocks on South Temple Street.

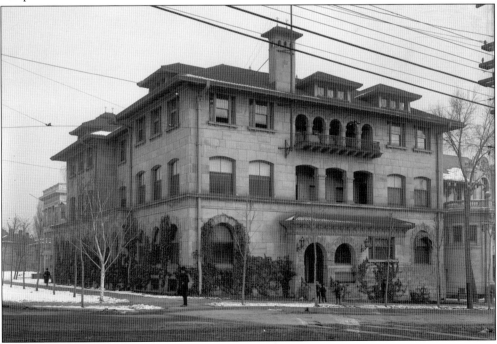

The Alta Club, at the corner of First East and South Temple Streets, was symptomatic of the development of a non-Mormon aristocracy by the beginning of the 20th century. The private club, pictured in 1905, had residential quarters, a bar, lounges, and dining facilities. Patronized by wealthy non-Mormons, it excluded women until late in the 20th century.

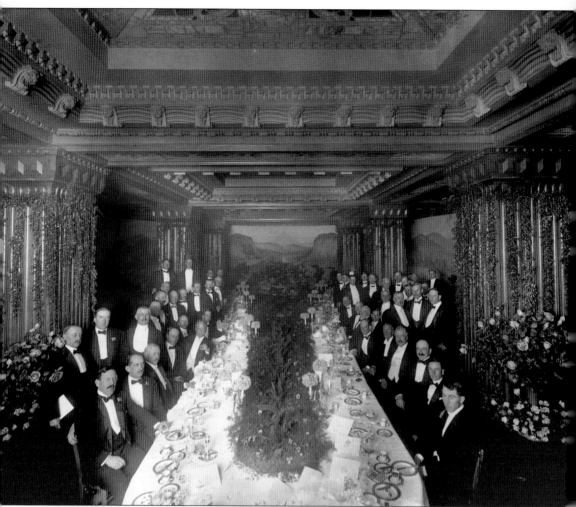

The Hotel Utah, at the intersection of South Temple and Main Streets, was built in 1911 as a cooperative venture by Salt Lake City business and ecclesiastical leaders at a cost of $2 million. This 1912 view of the Grill Room indicates that it was an elegant dining facility for well-to-do locals and travelers. Although the hotel was closed in 1987, converted into offices for the LDS Church, and reopened as the Joseph Smith Memorial Building, it still serves the public at its famous rooftop restaurant.

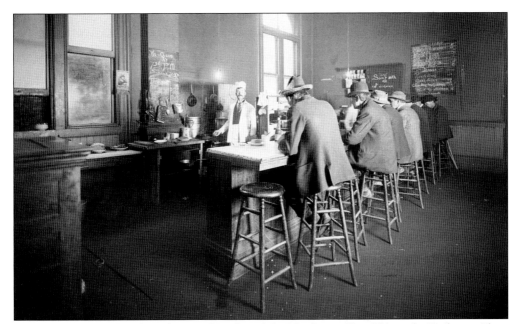

While such elegant hotels as the Hotel Utah and the Newhouse Hotel (near the Exchange Place financial district) served the needs of well-heeled locals and travelers, other diners were less fortunate. The Volunteers of America, a pseudo-military religious group probably patterned on the Salvation Army, ran this lunch counter in conjunction with a hotel, free pharmacy, and free employment agency at 115 East First South.

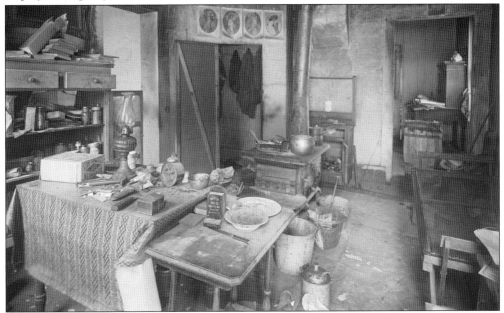

This scene shows the interior of a home at 130 North 300 West in Salt Lake City. Although mining, banking, railroads, commerce, and industry had created impressive levels of wealth in the city by 1915, when this photograph was taken, this home demonstrates that the life of common laborers remained grim. The picture was made for the Utah Board of Health, which might indicate that it was part of a Progressive social reform effort.

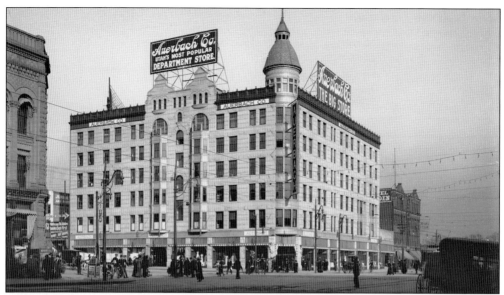

The modernization of the Utah economy is symbolized by the massive Auerbach Company department store at 300 South and State Street. For most of the 20th century, the Jewish Auerbach family provided stiff competition to the Mormon-owned Zion's Cooperative Mercantile Association, a church cooperative created by Brigham Young to try to freeze out such private, non-Mormon merchants as the Auerbachs. By the beginning of the 21st century, both companies had been beaten out by national chains.

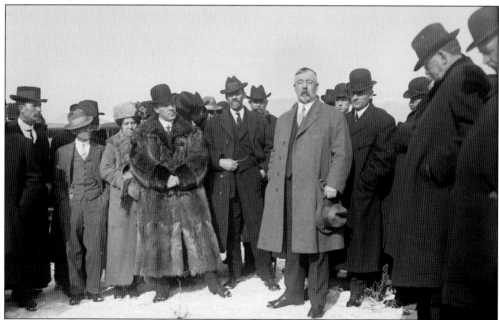

In this photograph, Gov. William Spry (hat in hand) stands amongst observers at the ground breaking of the new state capitol. Today fur coats for men conjure the caricature of 1970s pimps, but at the beginning of the 20th century, fur coats were a status symbol for both women and men. In the West, fur coats were often made from rabbits or beaver, protecting the wearer from the harshest of Utah's winters.

At the beginning of the 20th century, the middle class spent its disposable income in the new shops that sold manufactured goods in the city. Window dressers used color, flashing lights, and alternating scenery to lure customers. Window displays were unique to the American urban scene. This Consolidated Grocery and Meat Company window creatively displayed cans of evaporated milk, a product that does not necessarily shout "buy me!"

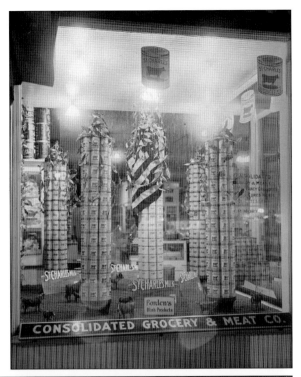

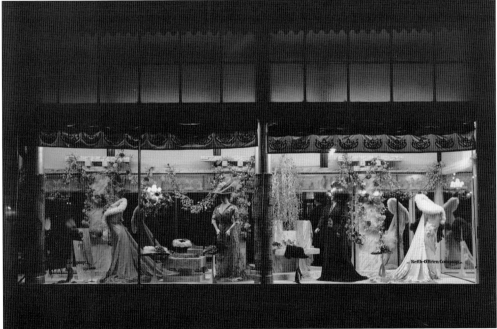

Used by dime museums throughout the 19th century, mannequins became a mainstay for shop windows by 1910. Mannequins demonstrated that ready-to-wear clothing looked as good as what the customer could make at home. In this shop window for Keith O'Brien, female figures are displaying a life of luxury and leisure, taking the viewer to another time and place—and implying that she could live a fabulous life of leisure if she purchased one of these garments.

Wagener Brewing Company was one of the first European commercial breweries in Utah. In the 1890s, Wagener advertised its Malt Tonic, which was "a strengthener and appetizer," and Brown Stout, recommended "for invalids and convalescents." The brewery burned to the ground two days after Christmas in 1914. With Prohibition on the horizon, the brewery was never rebuilt.

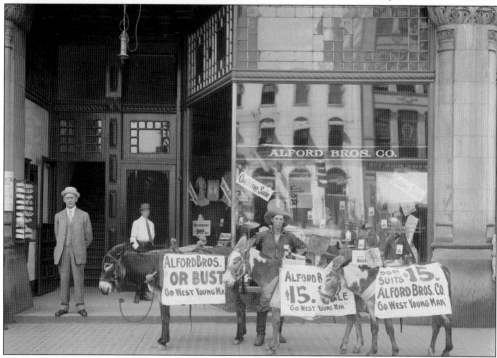

The Alford Brothers Company advertised in the 1911 city directory that it sold "only hats, furnishings, and clothes 'of the better sort'" for reasonable prices. The store's owners adopted New York journalist Horace Greeley's famous saying, "Go West, young man." The salesman is advertising $30 suits slashed to $15 by using a ubiquitous symbol of the West—donkeys.

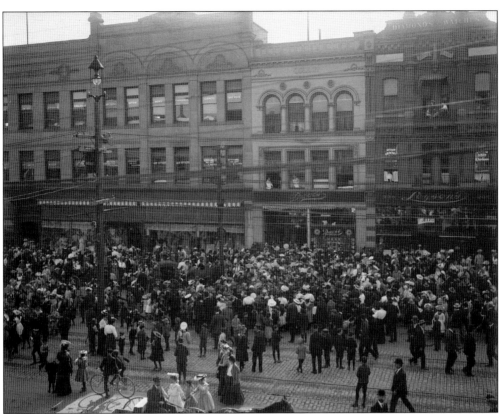

Buster Brown shoes were named after the famous comic strip character, who had a sister named Mary Jane (another shoe) and a dog named Tige. Brown Shoe Company hired little people to play Buster Brown who, accompanied by Tige, travelled across the country to perform in rented theaters, department stores, and shoe stores. These free performances often drew large crowds, as seen in this photograph at Davis Shoe Company in 1907.

Salt Lake City may have begun to look like a city during this time, but this 1898 photograph of Alt's Saloon downtown reminds us that Salt Lake was a Western city. Women who entered saloons opened themselves to suspicion of prostitution. Although some saloons had a partitioned back room for dining, respectable women could only dine if accompanied by a man. (Classified Photograph Collection.)

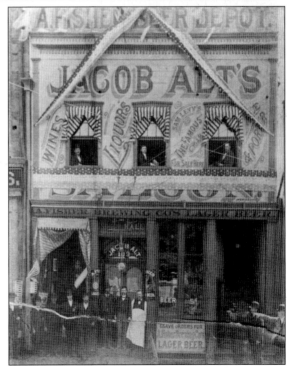

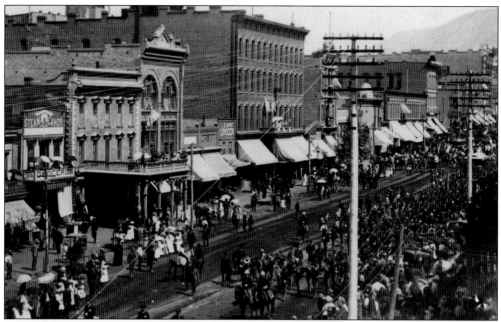

Between 1896 and 1899, over 600 African Americans lived with their wives and children on the outskirts of Salt Lake City, stationed at Fort Douglas as members of the 24th Infantry. Before the infantry's arrival, Utahns were concerned that the soldiers would fraternize with the city's white women. When the troops arrived, their professionalism assuaged most Salt Lake City residents' racial fears. Here the regiment is celebrated before being deployed in April 1898 to fight in the Spanish-American War. (*The Peoples of Utah* Collection.)

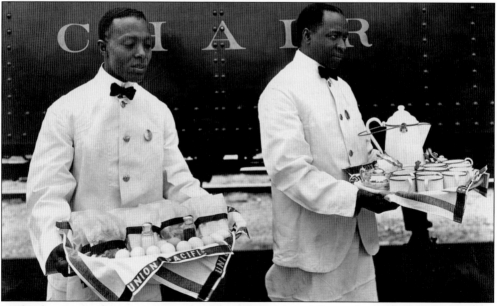

Utah's dominant white society, as elsewhere in the United States, limited job and education opportunities for African Americans. The majority of blacks in Salt Lake City worked in service industries like hotels and restaurants. These gentlemen are porters for the Union Pacific Railroad. (*The Peoples of Utah* Collection.)

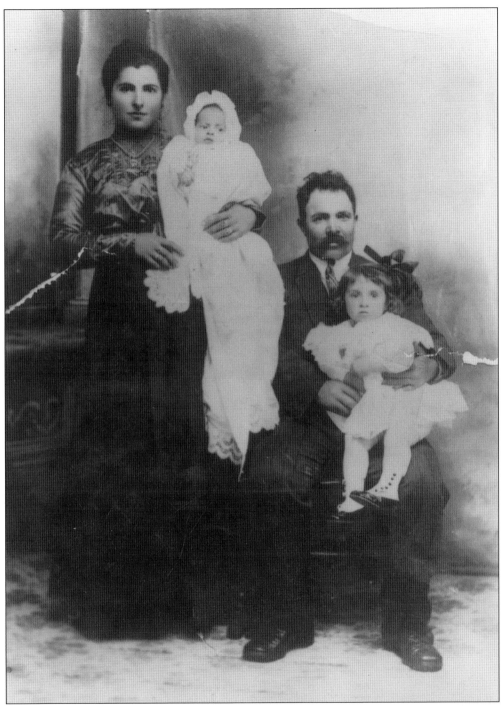

The majority of the Italians who immigrated to Utah did so between 1890 and 1920, pushed out of their home country by economic concerns and pulled to Utah and the West for opportunities in mining and railroad industries. By the mid-1910s, families such as that of Maria Giuseppe and Salvatore De Luca, shown here, purchased familiar food and other products in Little Italy, located on the west side of Salt Lake City. (*The Peoples of Utah* Collection.)

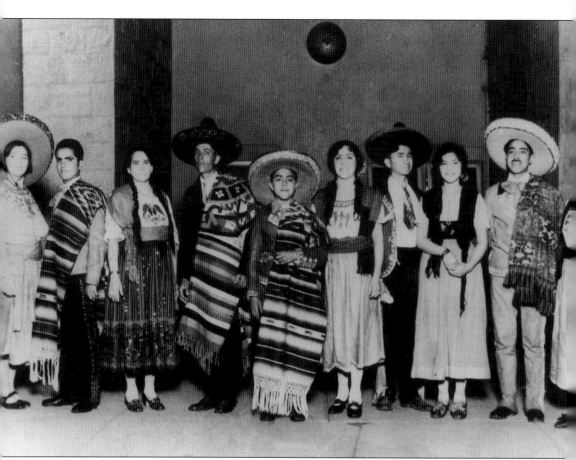

The LDS Church's extensive, worldwide proselytizing missions inspired converts to leave their countries and try their luck in Utah. They sought economic betterment among those who shared their faith. Latino converts attended services in specialized Spanish-speaking church wards, the equivalent of a Catholic parish. This photograph shows Lucero Ward members during a Mexican celebration at the Salt Lake Tabernacle in the 1920s. (*The Peoples of Utah* Collection.)

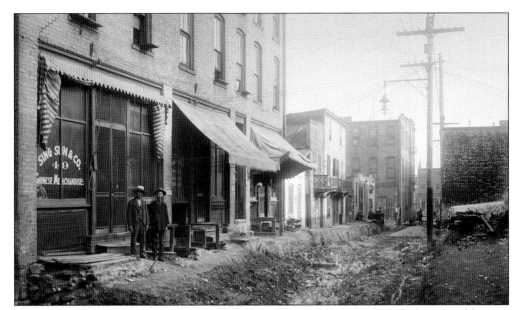

The 1890 census showed 271 Chinese residents of Salt Lake City, most of whom lived here in Plum Alley, a street in the middle of the block between State and Main Streets running from First to Second South. When the Central Pacific Railroad was finished in 1869, some of the Chinese laborers took up residence in Ogden, then migrated to Salt Lake City, where they ran laundries, grocery stores, and other businesses.

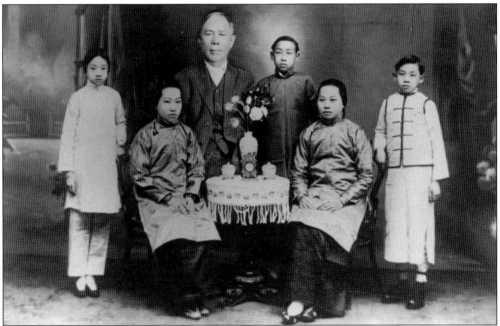

The overwhelming majority of Chinese immigrants in Utah were men who intended to work for a few years while they sent their earnings to their families back home. This photograph is an early version of photograph enhancement. The family, home in China, superimposed a separate photograph of their father to maintain a pictorial togetherness even though he was thousands of miles away. (*The Peoples of Utah* Collection.)

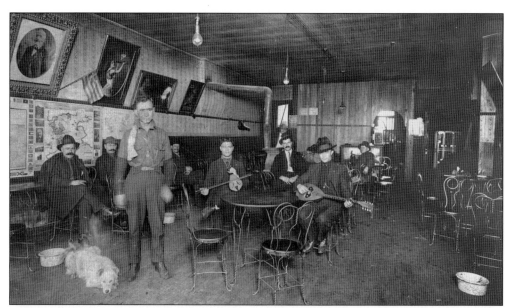

Greeks who chose to live and work in Salt Lake City instead of the mines formed a community on the western outskirts of downtown. Emmanuel Katsanevas (standing) owned the Open Heart coffeehouse in Greek Town. Open Heart was the center of the community, where men conducted business, discussed politics, and enjoyed familiar food and drink. (*The Peoples of Utah* Collection.)

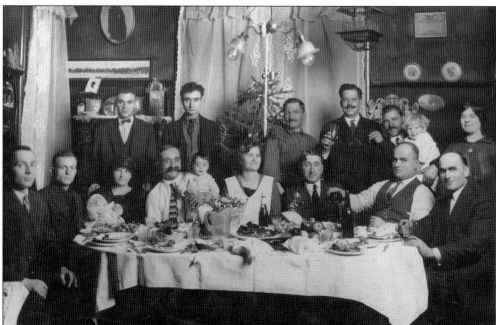

Greeks maintained their cultural identity through a strong community centered on the Greek Orthodox Church and its traditions, but by the second generation, Greek homes began to show signs of American influence. The home altar tradition lacked some of its original elements, and in this 1923 photograph, a family has incorporated the American Christmas tree into its holiday observances. (*The Peoples of Utah* Collection.)

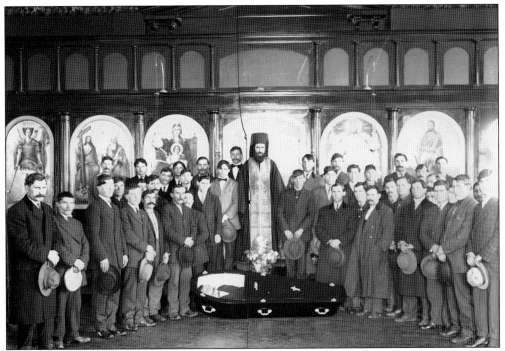

Although the 1900 census showed only three Greeks in Utah, just five years later, there were thousands who had come to work in the mines or railroads, and they erected Holy Trinity Greek Orthodox Church. In Salt Lake City, they formed a community centered on the church slightly to the west of downtown. Greeks were often assigned jobs that were more dangerous than others, and funerals like this one were common occurrences.

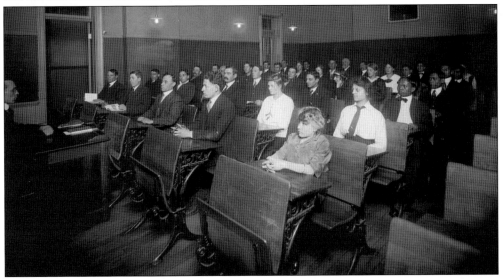

Greeks and Mormons clashed culturally in Salt Lake City. Mormons believed that Greeks were unable to assimilate, accusing them of being arrogant for believing their religion was the only true religion. Greeks felt the same way about Mormons. Progressive reformers offered Americanization classes, but a low percentage of Greeks actually took the classes. This photograph shows Greeks taking a night class at West High School in 1915.

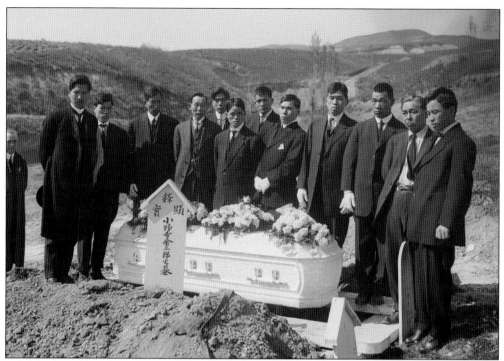

While other Utah communities like Bingham Canyon and Carbon County were ethnically more diverse than Salt Lake City in the early 20th century, there were at least representatives of many ethnic groups in the city. This Japanese funeral at the city cemetery in 1914 illustrates some of that diversity. There were over 2,000 Utahns of Japanese descent at that time.

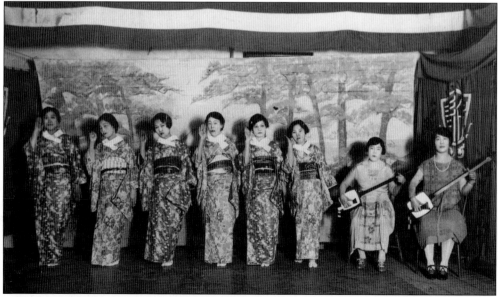

Several decades before Utah's complicity in Japanese internment during World War II, Japanese *Issei* (Japanese who were born in Japan but immigrated to the United States) found a home in Salt Lake City. The women's organization *Fujinkai* performed Salt Lake City's first folk dancing *yokyo* (entertainment), photographed in 1925. (*The Peoples of Utah* Collection.)

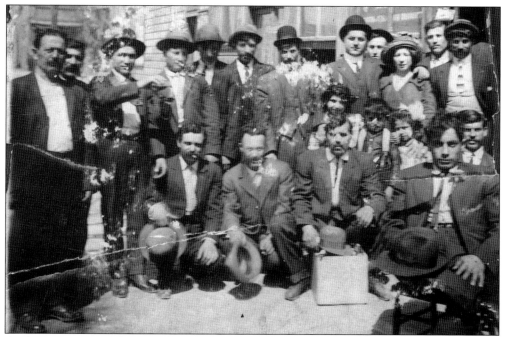

At the beginning of the 20th century, Lebanese men and women migrated through Mexico to avoid the ordeal at Ellis Island, where the paperwork was overwhelming and the health inspections invasive. Most of the Lebanese in Salt Lake City were part of Christian denominations. They interacted with Greeks, conducting business in Greek Town and peddling linens, cloth, lace, and jewelry downtown. (*The Peoples of Utah* Collection.)

Fort Douglas, a U.S. Army base on the east bench of Salt Lake City near the University of Utah, was founded during the Civil War to keep the overland mail route open (and to keep an eye on the Mormons as well). Its location in the interior of the continent also made it an ideal place to house German prisoners of war during World War I. This photograph shows a formation of such prisoners in 1917.

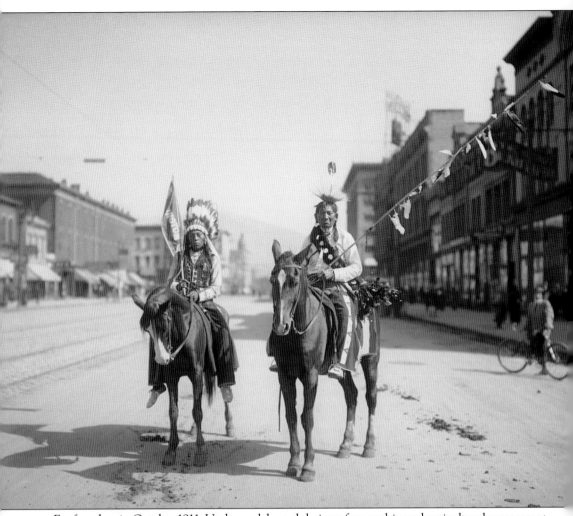

For four days in October 1911, Utahns celebrated their craftsmanship and agricultural successes at the state fair. This photograph is of an "Old West Show" probably connected to the fair. The Native Americans pictured here are in generic, Plains-style attire, an example of the general populace's tendency at the time to lump all Native American tribes into one convenient identity.

Three

POLITICS AND GOVERNMENT

Utah became a territory as part of the Compromise of 1850, but its bid for statehood over the next decades was repeatedly thwarted by its theocratic political system and its polygamous society. By the 1880s, both of those were becoming untenable under increasing federal pressure, and the decade of the 1890s saw the profound changes that led to statehood in 1896.

Political maturation during the period of this book continued to make rapid progress, symbolized in part by the construction of two awe-inspiring buildings: the City-County Building and the state capitol. Salt Lake City even saw the election of its first Jewish mayor in the person of transportation magnate Simon Bamberger. And during this period, Salt Lake City hosted visits by presidents William Howard Taft and Woodrow Wilson.

But politics in Salt Lake City had its sordid side as well. In 1915, the famous labor organizer and songwriter Joe Hill was executed at the state prison in Sugarhouse. While Hill was probably guilty of the murder with which he was charged, there is no question that his conviction and execution were orchestrated to send a negative message to labor radicals. There was a political underside in Salt Lake City life as well, symbolized by construction of the Stockade on the west side of the city to house prostitutes. A large debate ensued about the relative merits of confining the practice or trying to suppress it, a debate that involved the city's leading madam and the mayor.

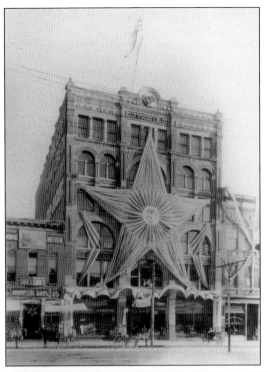

It took half a century before Utah became a state. Congress did not like Mormon bloc voting, and in 1856, the new Republican party declared that polygamy and slavery were the "twin relics of barbarism." Mormons struggled against popular opinion and numerous anti-polygamy laws, and in 1887, Congress passed the Edmunds-Tucker Act, which threatened to destroy the LDS Church by taking its temples, the cornerstone of the Mormon faith. To save the temples, LDS Church president Wilford Woodruff announced the end of polygamy in 1890. Once the polygamist threat was gone and Mormon leaders encouraged members to vote for both parties, Utah became the 45th state in the Union in 1896. The photographs show local businesses Dinwoodey's (left) and ZCMI (below) decorated for the celebration. (Both Classified Photograph Collection.)

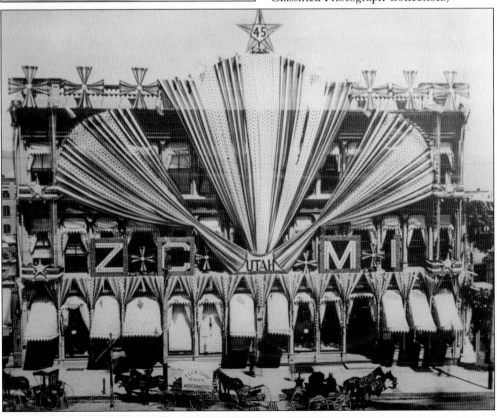

Women's suffrage was granted in 1870 in Utah, but it was hotly contested within the state. Anti-polygamists believed that women's suffrage was a form of self-imprisonment for polygamist women, believing that Mormon women voted according to religious dictates. Federal anti-polygamy legislation disfranchised Utah women in 1887. Upon Utah's statehood, women's suffrage was written into the state constitution. This photograph shows suffrage leaders Emily Richards (left), Sarah M. Kimball (center), and Phoebe Beatie in 1875. (Susa Young Gates Collection.)

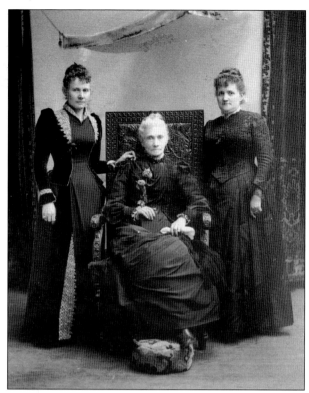

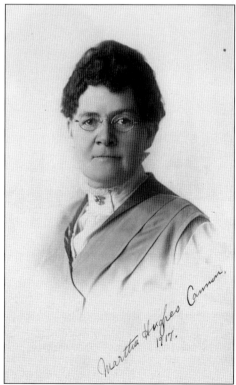

The fourth wife of Republican senator Angus Cannon, Martha Hughes Cannon ran against her husband as a Democrat in the 1896 election and won, becoming the first woman senator in the Utah State Legislature. A trained medical doctor, Cannon worked at Deseret Hospital before her political career. As a senator, Cannon advocated education for deaf, mute, and blind children, and she established the State Board of Health. Cannon's independence and intelligence belies common caricatures of polygamous wives as unthinking captives. (Classified Photograph Collection.)

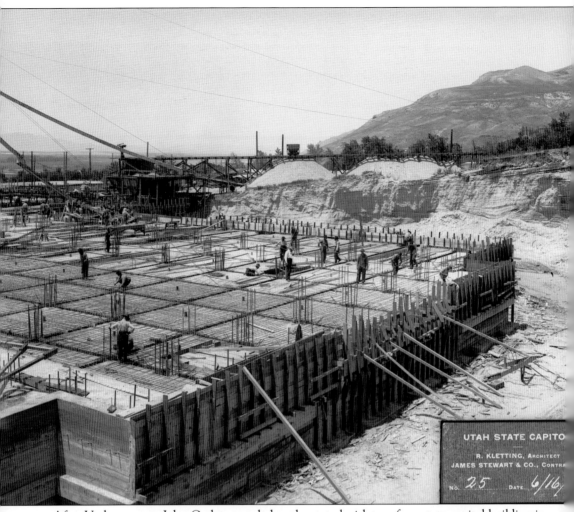

UTAH STATE CAPITO

R. KLETTING, Architect

JAMES STEWART & CO., Contra

No. 25 Date 6/16/

After Utah governor John Cutler appealed to the state legislature for a state capitol building in 1907 by reminding legislators that it had been 11 years since Utah became a state, the legislature struggled to find funding for construction. A state inheritance tax of almost $800,000 from railroad magnate E. H. Harriman provided the bulk of the funding for the $1-million building.

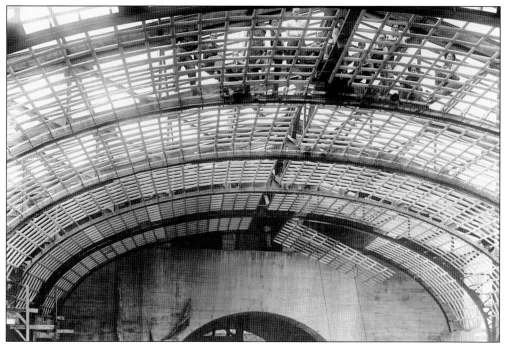

The building design competition was fraught with controversy, as the search for an architect broke 12 of the 14 guidelines of the American Institute of Architects (AIA), and professionals across the country urged architects not to enter the competition. However, Utah architects eventually broke with the AIA and entered the contest, and Richard Karl August Kletting designed the building.

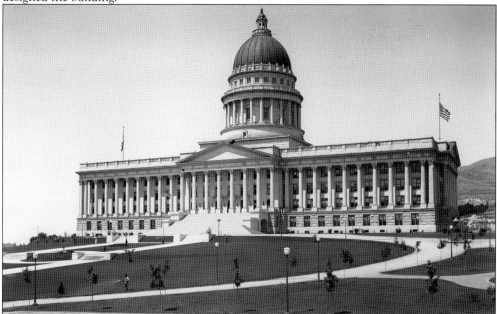

Finished in 1915, the Utah State Capitol building sits on a hill overlooking the city from the north. The columns on three sides of the building symbolize the classical architecture of Greece, the birthplace of democracy.

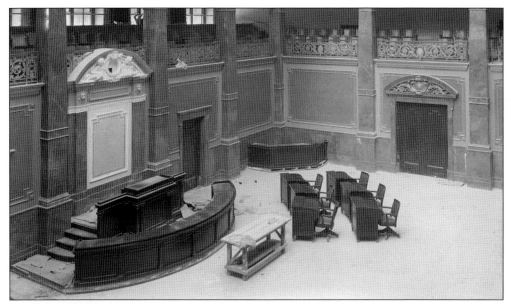

The Utah State Capitol under construction in 1915 symbolized the emerging political maturity of the city since Utah statehood in 1896. Designed in a classical style, the building's ornate interior has been a magnet for tourists from its beginning. The presence of legislators' desks in this photograph before the floor has even been finished seems to symbolize their impatience to get to work.

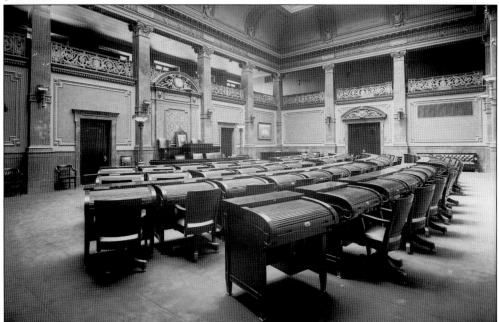

The Utah State Capitol has two symmetrical wings for two branches of government: the state supreme court and the Utah House of Representatives. Inside the capitol, marble ionic columns line the foyer beneath the rotunda, which is 165 feet high and painted with clouds and seagulls, the state bird. This photograph shows the inside of the House chambers, located in the west wing of the building.

Simon Bamberger, shown here in 1920 in the white hat in front of the Utah State Capitol, served as Utah governor from 1917 to 1921. A Jewish Democrat, Bamberger was a different person from the typical Mormon Republican governors the state has had before and since, and his governorship illustrates a developing cultural and political diversity the state was beginning to achieve.

Thomas Kearns made his millions through the Silver King mine in Park City. Elected to the U.S. Senate in 1900, he supported Theodore Roosevelt's environmental conservation programs. He did not win support for reelection, which left Kearns embittered toward the Mormon Church's political power. Kearns helped form the American Party, which opposed Mormon influence in the state's political matters. The party was successful only in municipal elections.

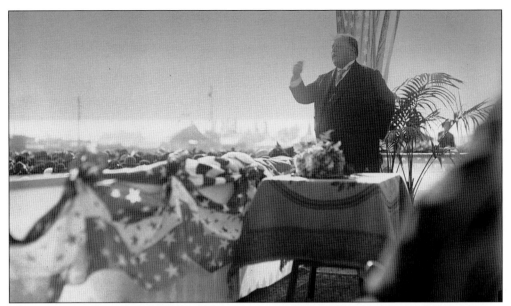

This is Pres. William Howard Taft speaking at the Utah State Fairgrounds in Salt Lake City in 1911. Although Utah had enthusiastically supported Democratic candidate William Jennings Bryan in its first national election after statehood in 1896, the state quickly shifted into the Republican column, from which it has rarely since strayed. In the three-way contest of 1912, Taft carried only Utah and Vermont against Theodore Roosevelt and Woodrow Wilson.

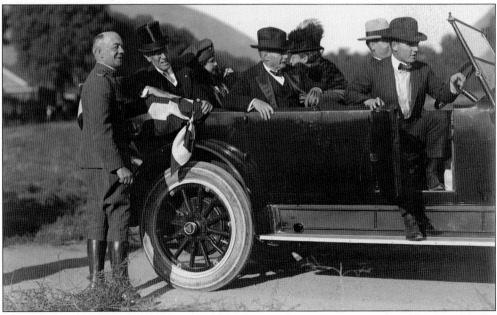

Pres. Woodrow Wilson is shown in a top hat visiting the U.S. Army base at Fort Douglas around 1915, during his first term. His next visit, in 1919, took place under much less happy circumstances, for World War I had intervened, and he made a quick stop in Ogden to give one of his speeches to try to persuade the American people to put pressure on their senators to ratify the Treaty of Versailles. The following night, after a similar speech in Pueblo, Colorado, he collapsed and never fully regained his health.

Despite the LDS Church's public abolition of polygamy in 1890, the U.S. Senate election of Reed Smoot in 1902 reopened the polygamy controversy. The Senate refused Smoot his seat, erroneously claiming he was a polygamist. Four years of senatorial hearings exposed that the LDS Church had in fact sanctioned polygamous marriages clandestinely since 1890. The church officially banned the practice, and Smoot finally took his seat in 1907, serving until his defeat in 1932. (Classified Photograph Collection.)

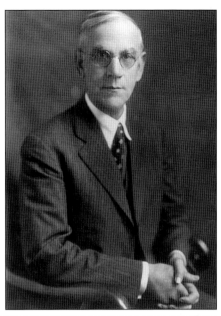

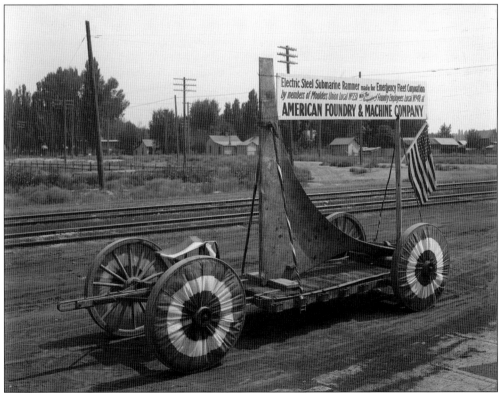

This "electric steel submarine rammer" made in Salt Lake City and exhibited on this Labor Day parade float reveals at least three things about life in the city: first, the city's emerging industrial economy; second, the fact that the city's factories were populated by unionized workers; and third, that events in other parts of the world could affect even Salt Lake City. World War I was almost over at the time of this September 1918 photograph.

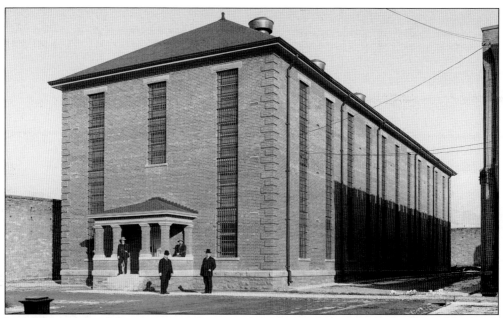

Joe Hill was a Swedish immigrant who arrived in New York in 1902. Disenchanted by harsh working conditions and workers' exploitations, Hill became a leading member of the national Industrial Workers of the World (IWW), a labor organization that advocated sabotage and violence if needed. Hill came to Utah to work the Park City mines in 1913. His folk songs "Rebel Girl" and "Casey Jones" gained notoriety among laborers worldwide. He was convicted of murder in 1914 on circumstantial evidence and given the death sentence. Hill spent over a year at the state penitentiary until he was executed by firing squad on November 19, 1915. He did not "want to be found dead in Utah," so his ashes were sent in envelopes to IWW headquarters across the country—except Utah. Hill's execution spelled the end for the IWW in Utah.

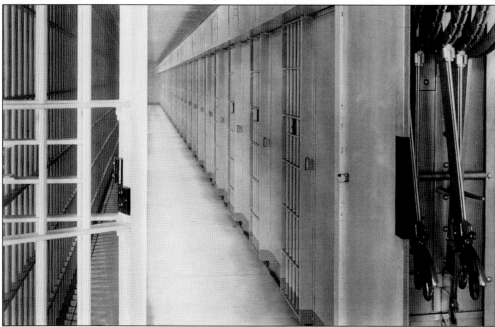

William Spry served as governor of Utah from 1912 to 1916. After receiving a barrage of appeals to grant Joe Hill a new trial for the 1914 murders, Spry refused both a new trial and a commutation of his sentence. Joe Hill was executed in 1915. Spry's inactivity in the Hill case brought several death threats on him and his family. Despite the controversy, Spry eventually became U.S. Land Commissioner under the Harding administration. (*The Peoples of Utah* Collection.)

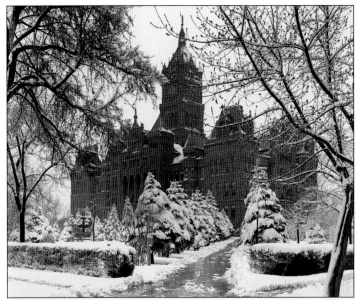

Salt Lake City's City-County Building is situated on its own block called Washington Square in the center of downtown. Constructed in the 1890s, it also housed the state legislature from statehood in 1896 to 1912, when the capitol building was completed. One of Utah's monumental buildings, it testifies to the emerging political and governmental maturity of the state by the beginning of the 20th century.

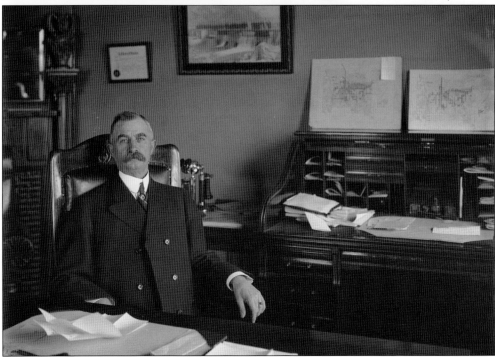

Mayor John Bransford (here in 1909) took office in 1907. Believing that prostitution was an inevitable evil and could not be eradicated, he investigated how cities outside of Utah regulated the practice instead. He created the controversial Stockade, a series of buildings meant to contain and control prostitution. However, despite the fact that Bransford committed his administration and the city's coffers to this project, the governor, law enforcement officials, and many voters opposed the Stockade because prostitution was still illegal, contained or not. The result was a three-year political struggle—the governor and police on one side and the mayor and city council on the other. The Stockade debacle heralded the end of Bransford's political career.

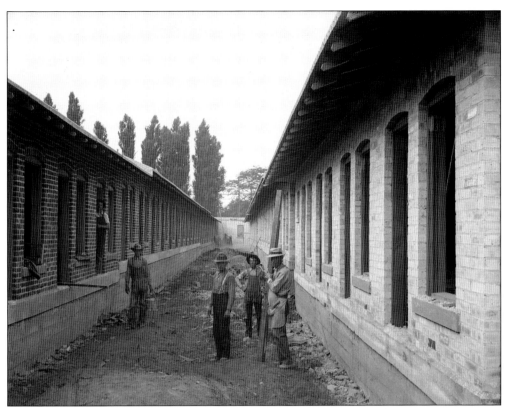

This photograph shows the construction of the Stockade, a 100-room red light district on the west side of the city within which the city government attempted to concentrate and regulate prostitution from 1908 to 1911. Prostitutes paid rent for their individual rooms, which ranged in price according to size and accommodations. Doctors examined prostitutes before they could work in the Stockade.

While she often went by the pseudonym Dora Topham, this woman's real name was unknown. Utahns knew her best, however, as Belle London, a leading madam of Ogden's brothels for nearly 20 years. In 1908, the Salt Lake City Council asked her to manage the Stockade. Topham was caught in the middle of a political battle between law enforcement officials and the governor, who opposed the Stockade, and the mayor and city council who employed her. Authorities arrested Topham for allegedly enticing a young woman into prostitution. She was convicted, but the Utah Supreme Court reversed her conviction. Her arrest marked the end of the Stockade, which was quickly razed and turned into a legitimate business district. (Classified Photograph Collection.)

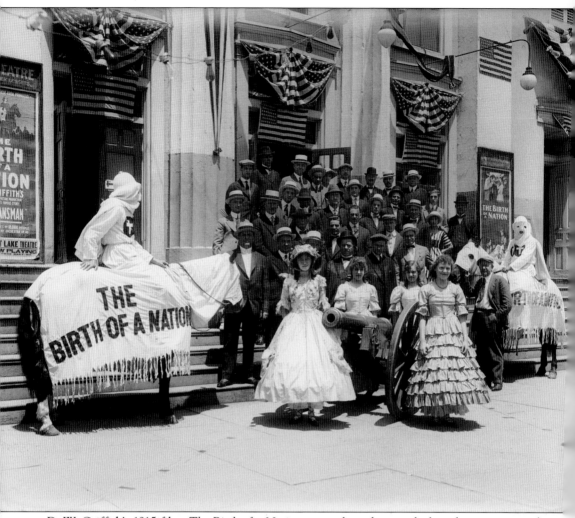

D. W. Griffith's 1915 film, *The Birth of a Nation*, was released a year before this promotional photograph was taken outside the Salt Lake Theatre. Controversial in its own day as it is now, the film romanticized the antebellum South and portrayed blacks as licentious and lazy. A new Ku Klux Klan emerged after the movie's release, and it became a powerful political and societal force in several major cities across the United States. A coalition of Masons, anti-Mormons, and non-Mormon businessmen formed Salt Lake City Klavern No. 1 in 1921 to combat Mormon economic power and advocate pure, 100-percent white Americanism. However, representing a small minority of people in the city, the klavern fell under the pressures of internal dissension and Mormon leaders' opposition.

Four

RELIGION, HEALTH, AND EDUCATION

Even before the period depicted in this book had begun, the Mormon monopoly of religious life in Salt Lake City was being considerably diluted by an influx of members of other faiths. While the Church of Jesus Christ of Latter-day Saints would remain dominant even into the 21st century, the city would also become increasingly diverse in religion. Members of Protestant denominations staffed missions and built schools as early as the 1860s, while the Catholic population increased dramatically with the opening of the mines in the 1870s, and Greeks began arriving at about the same time.

Health care improved dramatically during this time as well, beginning with the construction of St. Mark's Hospital (Episcopal) and Holy Cross Hospital (Catholic). Both facilities offered nurse training programs. Eventually, secular government entered the health care business with erection of the County Hospital on 2100 South. Eventually it became the headquarters of the University of Utah Medical School.

Perhaps the greatest changes, though, occurred in education. During the pioneer period, elementary and secondary education was given through schools in the Mormon wards (congregations), and it varied dramatically according to the quality of teachers available. Protestants and Catholics developed schools staffed by well-qualified teachers during the late decades of the 19th century, and part of Utah's preparation for statehood in the 1890s included development of an adequate public school system. Higher education included the University of Deseret (later the University of Utah) beginning in 1850, Westminster College supported by the Presbyterian Church, and the Catholic All Hallows College.

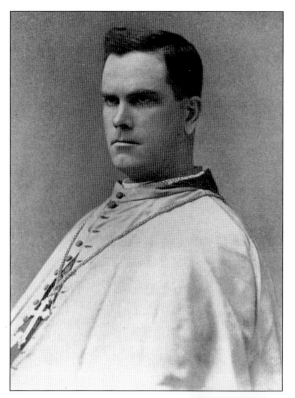

No more important figure has emerged in Utah Catholic history than Lawrence Scanlan (1843–1915), the first bishop of the diocese. Trained in his native Ireland as a missionary priest to minister to the Irish diaspora after the Potato Famine, Scanlan came to California in 1869. After ministering in Nevada mining camps for several years, he was sent to Salt Lake City in 1873. Scanlan's great vision was coupled with an immense fund-raising talent, and he harnessed much of the new mining wealth to build the Cathedral of the Madeleine, Holy Cross Hospital, All Hallows College, and other foundations. (*Peoples of Utah* Collection.)

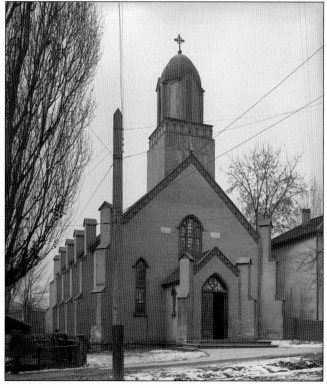

St. Mary's Church (later St. Mary's Cathedral) was the first Catholic church in Utah, situated on 200 East between South Temple Street and 100 South. Although it was a beautiful structure of yellow brick, Utah Catholics of the 1870s did not anticipate the immense growth in their numbers the mining industry would provide, and by the end of the 19th century, it had become inadequate in size. In 1900, the cornerstone for the present Cathedral of the Madeleine was laid, and within a few years, St. Mary's was sold and torn down.

Salt Lake City's Roman Catholic Cathedral of the Madeleine is nearing completion in this 1907 photograph, taken two years before its dedication. The city had become the seat of a diocese in 1891, and construction of the cathedral began in 1899 under the direction of its first bishop, Lawrence Scanlan. Scanlan's remains were interred in a sarcophagus beneath the original high altar; they have since been moved upstairs.

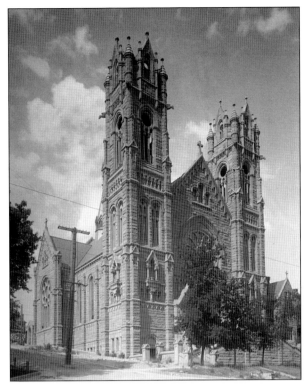

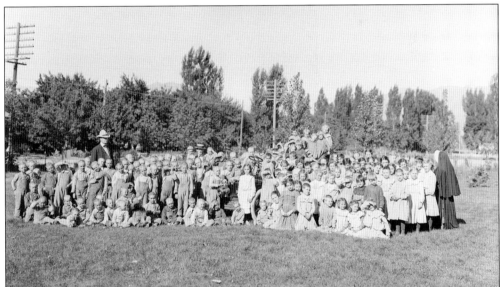

Funded by a $50,000 donation from Margaret Kearns, wife of the silver mining magnate Thomas Kearns, the Kearns-St. Ann's Orphanage opened on Twenty-First South Street in 1900. Mining was lucrative, but also dangerous, and the orphanage was the Kearns family's way of caring for the children of those who had paid the ultimate price while building the Kearns fortune. Staffed by Catholic sisters from the Holy Cross order, the orphanage was supported by substantial surrounding acreage in what was then the rural outskirts of Salt Lake City and grew much of its own food. In 1955, the building became St. Ann's School.

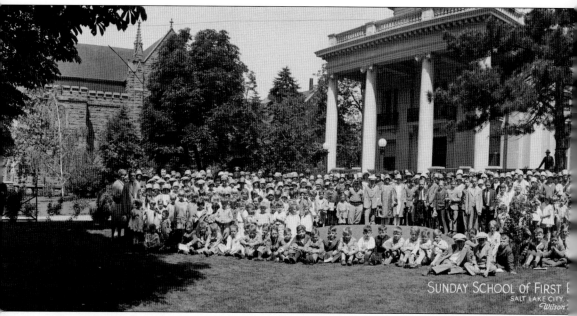

SUNDAY SCHOOL OF FIRST
SALT LAKE CITY,
Wilson's

This 1920s Sunday school class from First Presbyterian Church (background left) on the lawn of the Enos Wall mansion is a manifestation of Salt Lake City's thriving religious diversity. When

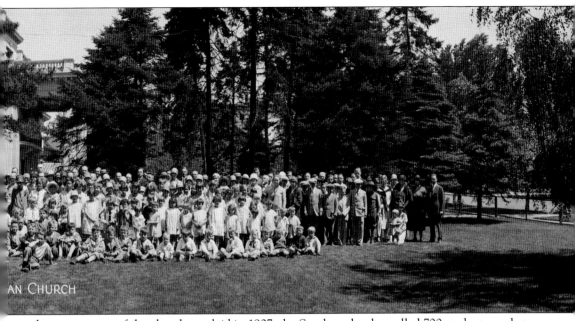

the cornerstone of the church was laid in 1907, the Sunday school enrolled 700 students, and at the time the church opened for worship on April 16, 1905, it had over 1,000 members.

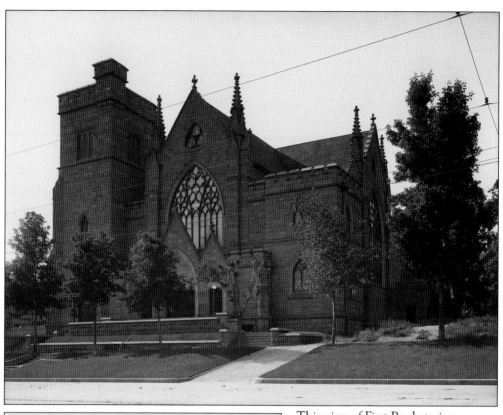

This view of First Presbyterian Church shows its impressive facade on South Temple Street. The church, completed in 1905, was part of a boom in construction of non-Mormon churches: the Roman Catholic Cathedral of the Madeleine is right across the street, and First Methodist was built within about four blocks of First Presbyterian.

Second only to the British Isles, Denmark was a fertile field for Mormon missionaries in the 1850s. Most converts settled on farms in central Utah and remained faithful to their new-found religion, but others discovered that farm life or Mormonism were not what they had wanted and returned to their native Lutheran faith in Salt Lake City. This photograph shows the Danish Evangelical Lutheran Church on E Street and First Avenue (later the African Methodist Episcopal church).

By the end of the 19th century, the Episcopal Church had a good foundation in Salt Lake City. St. Mark's Cathedral was consecrated in 1874, four years after St. Mark's Parish was formally organized. Bishop Daniel S. Tuttle, who served Utah's Episcopalian community from 1867 to 1886, was an outspoken opponent of polygamy in the region. After polygamy's downfall, Bishop Tuttle and Mormon leadership maintained a cordial relationship.

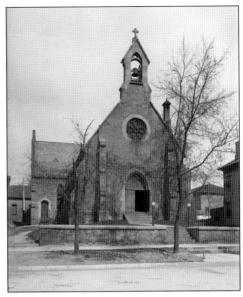

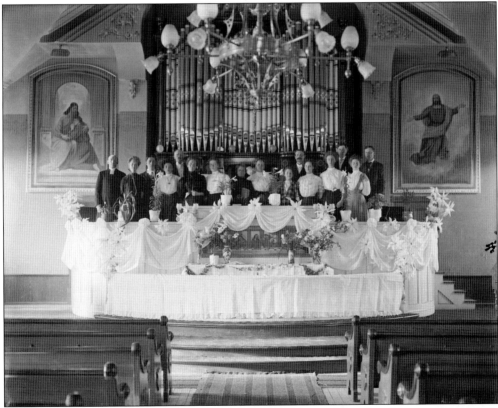

The choir of the Swedish Lutheran Church is posed in front of the church organ on April 22, 1908, probably at Easter. Although the first Swedes to come to Utah were Mormon converts in the 1850s, by the 1880s, most Swedish immigrants were non-Mormons (Lutherans, for the most part) who found employment in the mining industry. By 1910, there were over 17,000 Swedish-born Utahns, placing the state fifth in the country in that ethnic group.

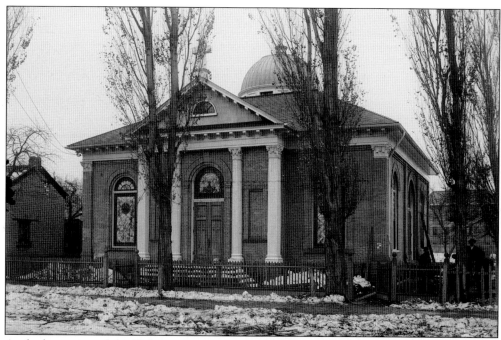

At the beginning of the 20th century, the city's Greeks lived and socialized near the industrial sector known to outsiders as Greek Town. Greek men immigrated to the United States looking for work so they could send income home to their families, but once women arrived, the Greek community found some permanence. Women maintained religious and cultural holidays and traditions, and once the Holy Trinity Greek Orthodox Church was built in 1905, the church became the heart of the Greek community.

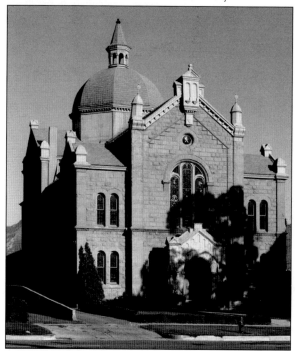

B'Nai Israel Temple was finished and consecrated in 1891. The prosperous Auerbach family brought their German nephew, Philip Meyer, to Salt Lake City to design the new synagogue. The Byzantine-style temple is a replica of the Great Synagogue in Berlin, destroyed during the Nazi *Kristalnacht* and bombing raids. Meyer never made it out of a concentration camp to see his aunt and uncle again and worship in the building he designed. (*The Peoples of Utah* Collection.)

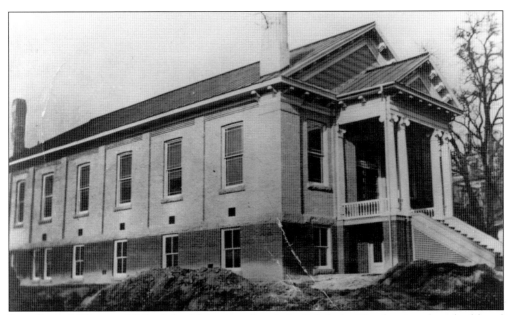

Rev. Samuel Eliot established the Unitarian church in Salt Lake City hoping that the liberal church would appeal to Eastern transplants and disaffected Mormons. During his visit in 1909, President Taft attended services in Unity Hall (photographed here in 1903). Congregants had difficulty finding a chair large enough for the president, and witnesses reported he had no money for the collection plate. Fortunately, his aide put a silver dollar on the plate for both of them. (Classified Photograph Collection.)

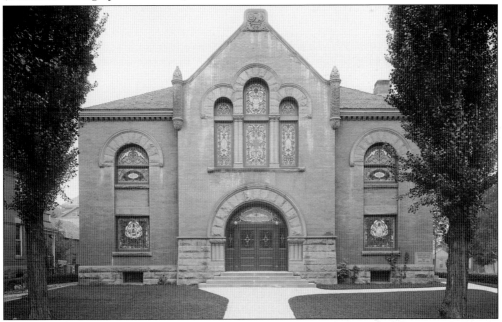

The First Church of Christ, Scientist, at 336 East 300 South, shown about 1910, was an imposing structure that illustrates the religious diversity of the city hidden under its Mormon facade. Founded by Mary Baker Eddy in the late 19th century, Christian Science flourished in the early 20th century all over the country, obviously including Salt Lake City.

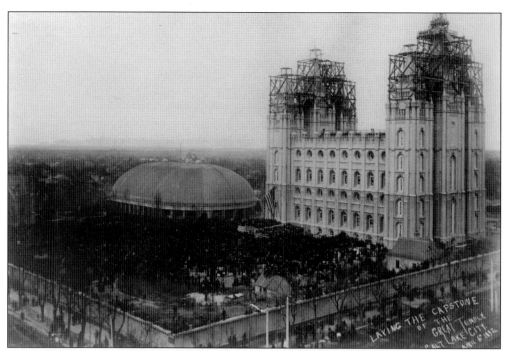

Forty years after its original ground breaking, the LDS Temple in Salt Lake City was completed in 1893. The photograph above depicts the capstone ceremony, held on April 6, 1892. The Gothic-inspired edifice is 210 feet at the highest of its six spires. A golden angel Moroni, a prophet in LDS scripture, stands atop the eastern spire. The temple is made of quartz monzonite (which looks like granite), which was hauled by oxen from Little Cottonwood Canyon 20 miles away until the transcontinental railroad arrived in 1869. Three other temples were finished in Utah before the Salt Lake City temple, but it is the largest and most recognizable of all the temples. Its completion was a symbol of Mormon perseverance as they strove to establish Zion in the West. (Both Classified Photograph Collection.)

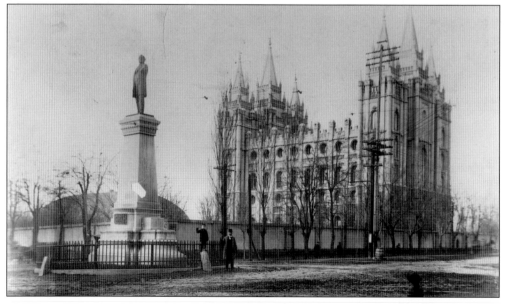

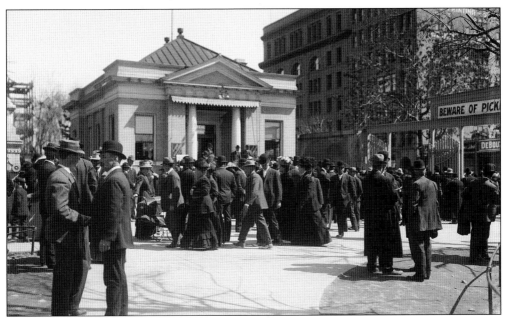

The Church of Jesus Christ of Latter-day Saints holds general conferences in the spring and fall. This 1910 photograph shows part of the crowd on Temple Square at Spring Conference, indicating that despite the increasing diversification of the Utah population, Mormonism was still a major force in cultural life. The sign, which appears to say "Beware of Pickpockets," indicates that Mormon moral values were not practiced by all Salt Lakers.

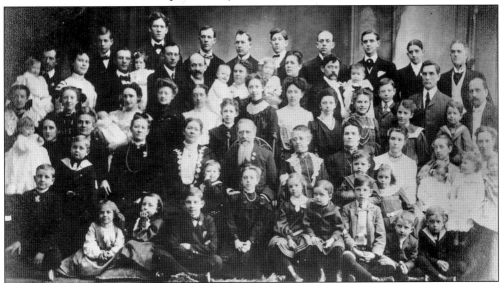

Joseph F. Smith was president of the LDS Church from 1901 to 1918. Although the church publicly abandoned plural marriage in 1890, Smith testified at the Reed Smoot senate hearings that the church continued to sanction plural marriages. Shortly thereafter, Smith publicly announced the end of polygamy for good. Smith and his wives are visible in the second row of this family photograph. Beginning with the second person, from left to right are Mary Taylor Schwartz, Edna Lambson, Juliana Lambson, Joseph F. Smith, Sarah Ellen Richards, and Alice Ann Kimball. (Classified Photograph Collection.)

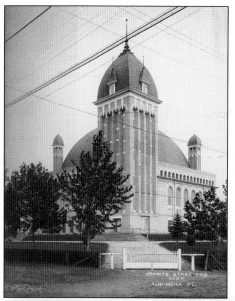

The LDS Granite Stake Tabernacle at 3300 South State Street, pictured in 1910, illustrates two significant facts about Salt Lake City history around the beginning of the 20th century. For one thing, its highly original architecture is a holdover from the pioneer period, when Mormon ecclesiastical design was creative and dramatic, contrasting with the "standard plan" church buildings of the later 20th century. Also, it indicates dramatic suburban population expansion.

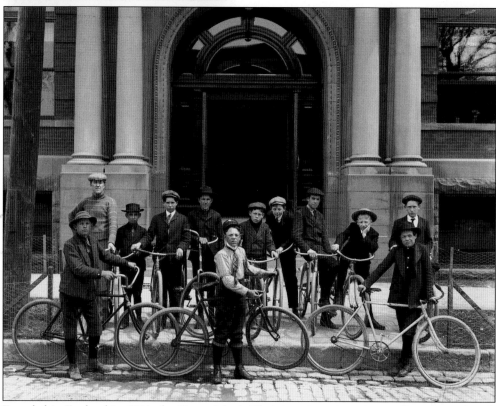

Founded in England in 1844, the Young Men's Christian Association was a Protestant church organization designed to provide a refuge for young men moving from a rural to an urban environment who might succumb to temptations or immoral behavior. YMCAs ordinarily provided living quarters, a library, a gymnasium, and meeting rooms. Organized activities, too, were part of the YMCA program, like this 1906 outing of the YMCA Bike Club.

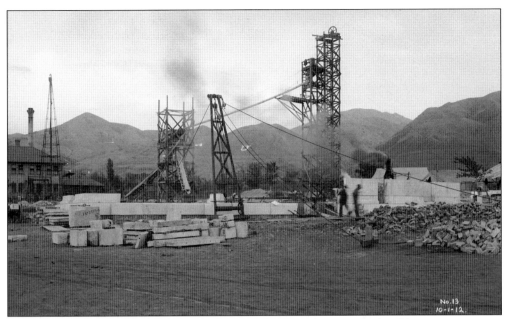

The University of Utah, founded in 1850 as the University of Deseret, is the oldest state university west of the Mississippi River. After moving from one site to another in the city, the University of Utah received a congressional grant of 60 acres on the east bench of the valley in 1894 from Fort Douglas. Classes began there in 1900. This 1912 photograph shows construction of the Park Building, the administrative center of the university. Built with white oolite limestone from central Utah, the regal structure offered a dramatic contrast to other university facilities.

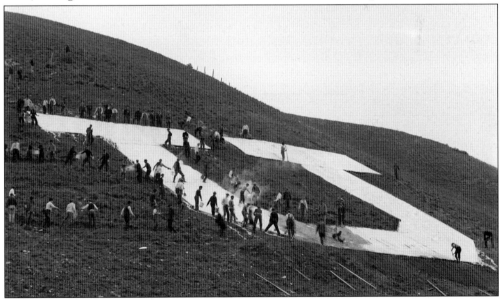

The University of Utah's "Block U" on Mount Van Cott overlooks the Salt Lake Valley. Designed in 1905, concrete for the Block U was poured in 1907. Erosion and disrepair threatened the Block U until 2006, when philanthropists raised enough funds to renovate the monument and maintain its tradition of flashing lights when the university football team wins a game. This image shows students whitewashing the Block U in 1911.

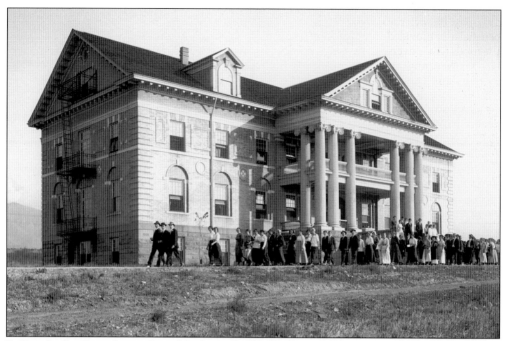

R. Douglas Brackenridge, author of the history of Westminster College, grounds the school's origins "in Presbyterian and Mormon history, making it one of the truly unique educational institutions" in the country. In addition to its commitment to liberal arts education, the school's founders envisioned the institution as a means to "convert and integrate Mormons into mainstream American culture." By the time these photographs were taken in the 1910s, the anti-polygamy crusade was finished, and the school functioned as a high school and junior college. Its administration was still trying to do some damage control from previous leaders who were ardently and vocally anti-Mormon. The school would maintain its hybrid form until the 1930s, when it solely operated as a college. The photograph above shows Ferry Hall, where Tanner Hall now stands. The photograph below shows a western view from the gate, with Converse Hall on the left and Ferry Hall on the right.

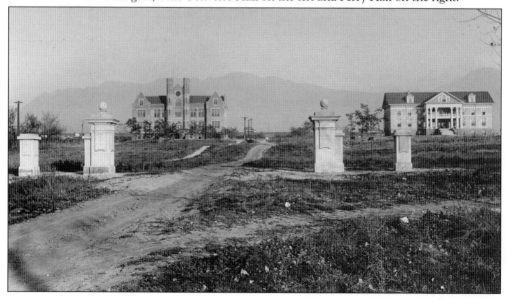

Two loyal Presbyterian beneficiaries provided the funds for Converse Hall on Westminster's campus. Finished in 1907, it sat empty because the college did not have funds to furnish or heat the building until 1911. To Westminster alumni, the building conjures memories of the special mentoring relationship that exists between Westminster's faculty and students and the long-lasting friendships forged on an intimately small campus.

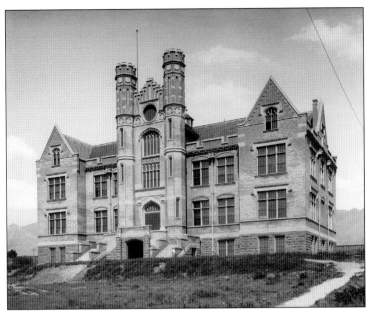

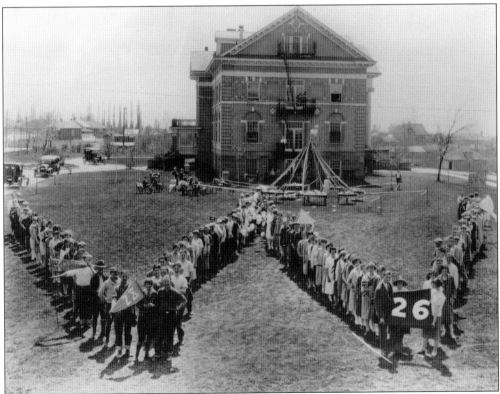

Westminster College was originally a mission school for the Presbyterian Church in Salt Lake City. Founded in 1875, the school became recognized for its academic excellence at the beginning of the 20th century due to the success of its graduates in universities and graduate programs in the East. This image depicts a May Day celebration with students representing the classes of 1926 to 1929. (Classified Photograph Collection.)

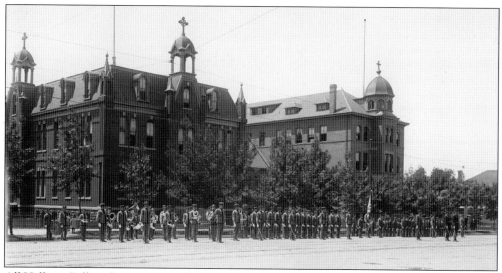

All Hallows College for men was built by Roman Catholic bishop Lawrence Scanlan in the 1880s. Its impressive academic program drew students from all over the country. The college had both a band (pictured to the left of the formation) and an orchestra, and its athletic program fielded no fewer than four football teams. Although the college closed in 1918, the building continued to serve as a National Guard armory until the 1940s.

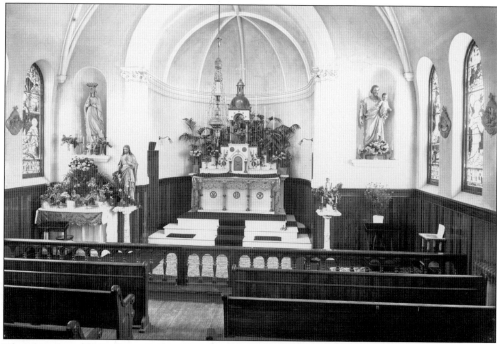

The chapel at All Hallows College for men was one of the most beautiful Catholic churches in Utah. This chapel ironically embroiled Bishop Lawrence Scanlan, who had built the college, in a conflict with the Marist Fathers who ran it. The college was located at 400 East 200 South, only three blocks from Scanlan's Cathedral of the Madeleine, and when Scanlan learned that cathedral parishioners often preferred to attend mass at the college, he forbade the Marists from offering mass for anyone but college personnel.

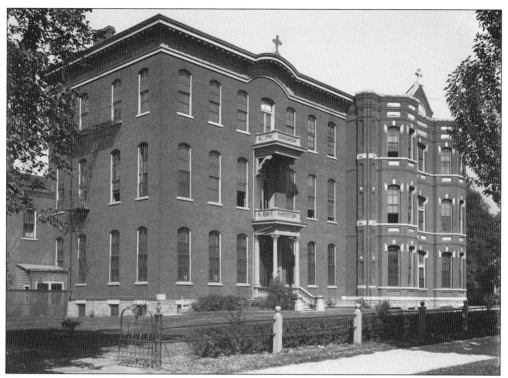

Education during Utah's pioneer period was very uneven in quality. Most schools were run by Mormon wards (a geographic unit similar to a Catholic parish) and staffed by people who were often poorly educated themselves. In 1875, Fr. Lawrence Scanlan, later the first bishop of the Salt Lake City diocese, invited sisters from the Holy Cross order to establish St. Mary's Academy for Girls, which helped improve schools in the city by teaching members of other faiths as well. By 1911, the school was in this impressive building.

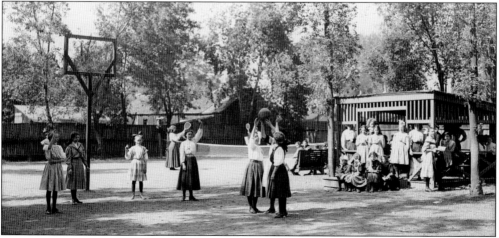

These schoolchildren are enjoying recess on the playground at St. Mary's School for Girls, founded by the Catholic Holy Cross sisters in 1875. The school was located at 146 South 100 West, on the grounds of the present Salt Palace. In 1926, the school moved to spacious and scenic acreage overlooking the valley at the east end of 1300 South. Known then as St. Mary of the Wasatch, the school continued in operation until the early 1970s.

Rowland Hall School for Girls on B Street was founded by the Episcopal Church in 1880 as part of the church's missionary effort in the state. It was the counterpart of St. Mark's School for Boys, which had begun in 1873. Both schools were intended as alternatives to Salt Lake City's public schools, which were erratic in quality. The two schools combined as Rowland Hall–St. Mark's in 1964.

As part of their physical education, Salt Lake High School's female students practiced a number of dances throughout the school year. Approximately 500 girls performed the dumb bell drill, skirt dance, wild bird mazurka, the hyacinth, and other folk dances on Governor's Day, May 25, 1911. The 100 sophomores in this photograph began the show with the Indian club drill.

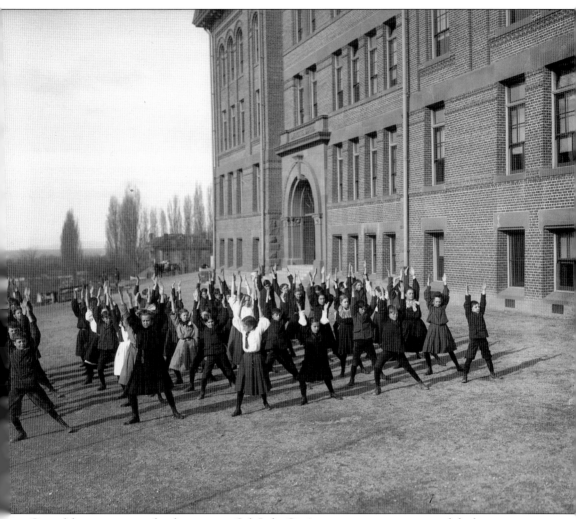

One of the conspicuous developments in Salt Lake City's maturation process around the beginning of the 20th century was the creation of a good public school system. The old ward schools of the 19th century, taught by people of widely varying backgrounds, might have sufficed for the simpler needs of a pioneer society, but the new century imposed more challenging needs. Mrs. Johnson's class at Lafayette School between First North and North Temple Street is getting prepared for a day's work in 1906 by a round of calisthenics. The school was totally destroyed by a fire in 1922.

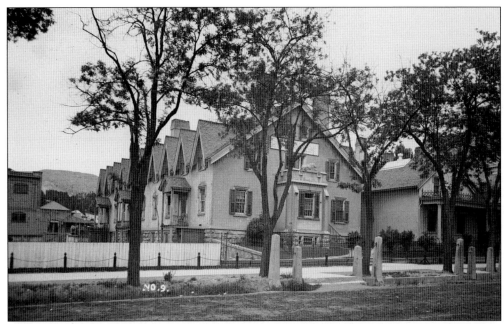

Truman O. Angell, architect of the Salt Lake Temple, designed Brigham Young's Lion House in the 1850s. The three-storied home's residents were never static—they came and went, shifting rooms often. After Young's death in 1877, the LDS Church owned the building, eventually using it as an extension of LDS University's campus. By the time these photographs were taken in 1910, the building provided classrooms for home economics courses, a cafeteria on the first floor, and housing for female students. The photograph below shows an instructor with students in the Lion House's nursery. Today the Lion House hosts large parties and receptions, and the old cafeteria is home to the Lion House Pantry, which offers traditional Mormon recipes served cafeteria-style by employees dressed like pioneers.

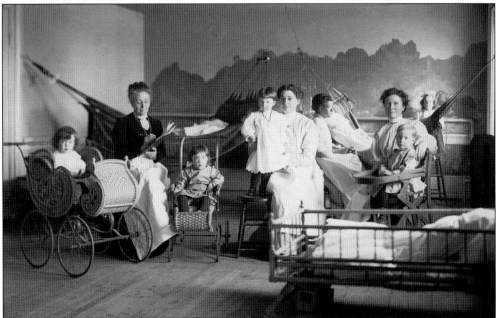

Salt Lake City's burgeoning capitalist economy is exhibited in this 1906 photograph of students at LDS University (later LDS Business College). They are learning to take dictation from a recording device called a "graphophone." Interestingly, almost half of this class of potential secretaries consists of men.

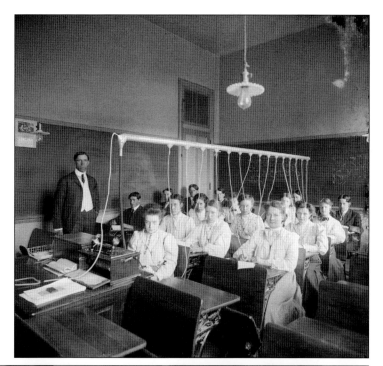

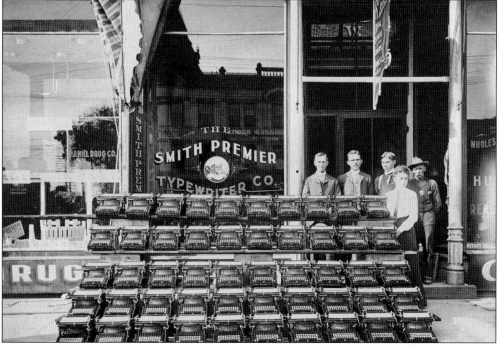

Founded in 1886, LDS University was part of the economic transformation that changed Utah in the late 19th century from an almost exclusively agricultural economy into a largely capitalistic one. This 1903 photograph shows one way in which the institution tried to remain abreast of the technological innovation that accompanied the economic changes, as well as the rise of a new class of merchants.

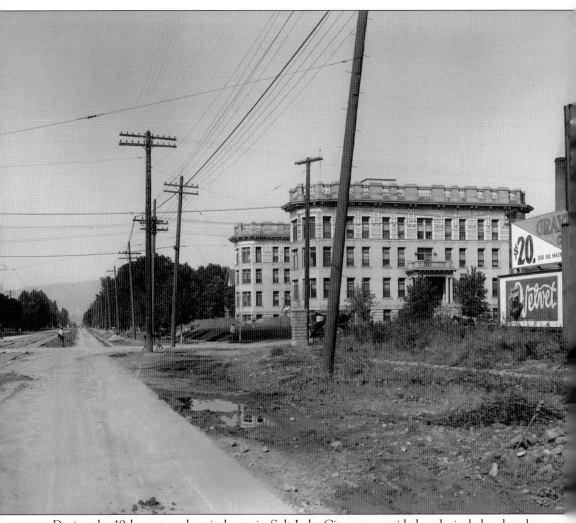

During the 19th century, hospital care in Salt Lake City was provided exclusively by churches: St. Mark's (Episcopal), Holy Cross (Catholic), and LDS (Mormon). Like public education, public health care emerged around the beginning of the 20th century. This 1917 photograph shows Salt Lake County General Hospital at 21st South on State Street, the only public hospital in the city. In 1942, it became the University of Utah medical school; it was eventually demolished and replaced by the Salt Lake County office complex.

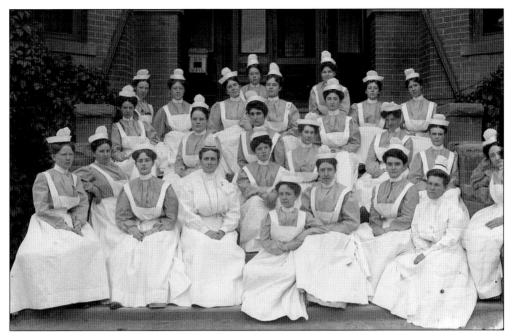

These nursing students from St. Mark's Hospital lived a highly regimented life during their three-year accreditation program. The program emphasized both coursework and hands-on experience at the hospital. Each nursing student was required to wear the blue-and-white striped seersucker uniform with the white apron, cap, cuffs, and linen collar. The two women in white are instructors, and their status as registered nurses is represented by the black band on their caps.

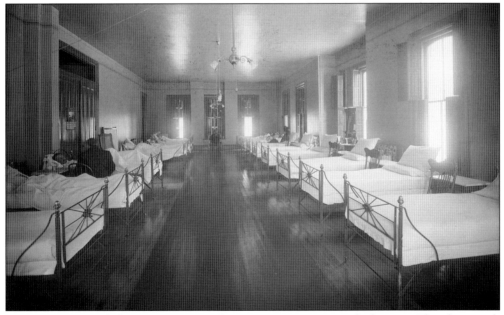

Catholic nuns founded Holy Cross Hospital in 1876 to serve impoverished miners. This photograph of a hospital wing was taken in 1908, but 10 years later, the beds would be filled during the influenza pandemic. The disease afflicted 40,000 Utahns and killed 1,200. Worldwide, the flu killed more people than World War I.

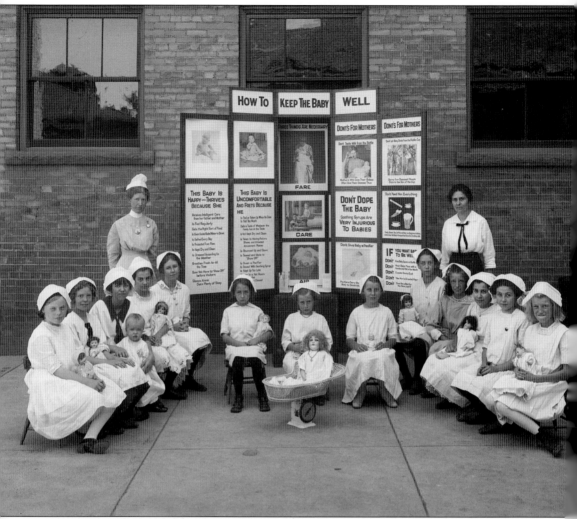

When this photograph was taken in 1914, girls' education included domestic training. The nursing caps and dolls suggest that these students studied infant care. Note that one student has a toddler with her. The display behind the students explains "How to Keep the Baby Well," informing students not to "Dope the Baby" or drink from the baby's bottle.

Five

RECREATION
AND CULTURE

Urban residents have a luxury generally denied to farmers—the weekend. As the work week throughout the nation during this period declined from six days to five, the need for ways to spend that leisure time grew correspondingly. Opportunities for popular entertainment were many in Salt Lake City. Sports fans could enjoy bicycle races at places like Wandemere Park or watch Tony Lazzeri swat home runs at the Bonneville Park baseball field. People seeking respite from the summer heat in the city could ride the Emigration Canyon Railroad through the wooded canyon to an impressive mountain vista at the quarry at the end of the line. Canoeing, boating, and other water activities were available at Liberty Park in the city or at the Lagoon in Farmington. The exotic Saltair resort on the shore of Great Salt Lake, a relaxing train ride to the west of the city, offered band concerts, dancing, rollercoaster rides, swimming, and other activities.

Nor were more serious forms of entertainment lacking. The Salt Lake Theater of pioneer days was still in use, but impressive newer facilities like the Orpheum Theater (later the Capitol Theater) and the Salt Palace offered alternative venues for stage plays, musical concerts, and eventually motion pictures.

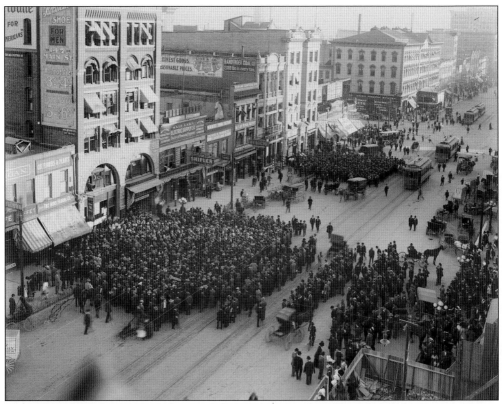

The 1909 World Series was a close match. The Pittsburgh Pirates played the Detroit Tigers, alternating wins to become the first teams to go all the way to Game Seven. In the days before radio, baseball fans got their sports news through ticker tape, the telegraph office, and the local newspaper. Here, a large group of men gather outside the Salt Lake Tribune Building (foreground) and the Salt Lake Herald Building (background), waiting to hear that the Pirates won the series.

Salt Lakers shared America's passion for the national pastime at Bonneville Park on State Street between Seventh and Eighth South Streets. In 1925, the year before he joined Babe Ruth and Lou Gehrig on the New York Yankees, the power-hitting second baseman Tony Lazzeri hit a minor-league record 60 home runs over Bonneville's short left field fence.

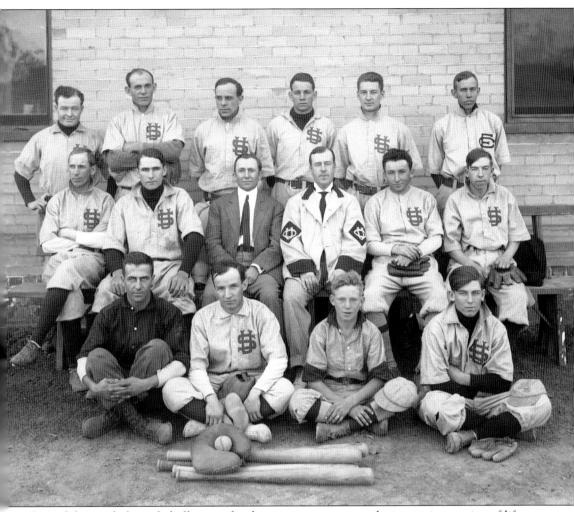

One of the psychological challenges of a changing economy was the increasing routine of life. People in white-, blue-, and pink-collar jobs punched in and punched out at the same time every day. In order to curb union activity, businesses created the notion of "welfare capitalism," offering benefits to keep employees content and loyal. As part of this impulse, many companies across the country formed sports teams for their employees, like the U.S. Smelter Baseball Team photographed here in 1912.

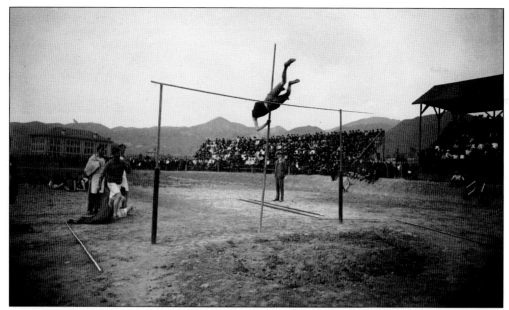

When the University of Utah moved to its current east bench location in 1900, its athletic facilities were initially quite primitive. This pole-vaulter is using an old-fashioned wooden pole that does not propel him very high—a fortunate circumstance, given the fact that all he has for a landing pad is a patch of loose dirt.

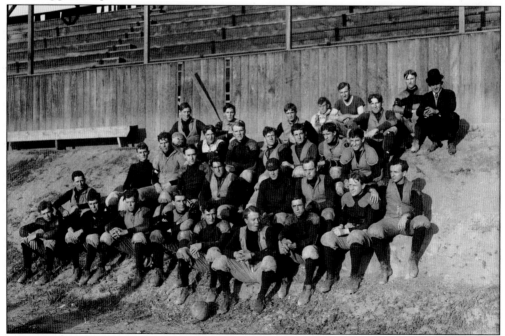

This 1907 photograph of University of Utah football practice, showing the ramshackle grandstand and muddy field, indicates that athletics was not yet a major part of campus life. Academic development was equally slow, and despite some distinguished faculty members and graduates during the interwar period, the university did not become a major research and academic center until after World War II.

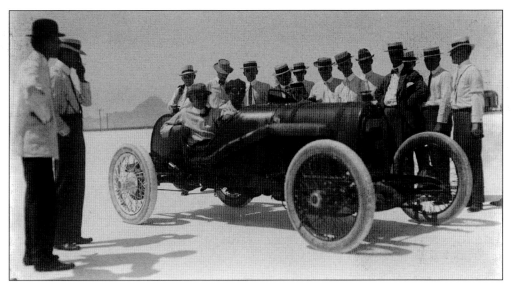

The Bonneville Salt Flats are a remnant of the Pleistocene-era Lake Bonneville, made up mostly of potash salts ranging between 1 inch and 6 feet thick. The flats were daunting to westward pioneers, but automobile drivers found a playground on the expansive, smooth surface. This photograph was taken in 1914, but it was decades later when Ab Jenkins beat an excursion train by 10 minutes, making the flats a home for automobile racing.

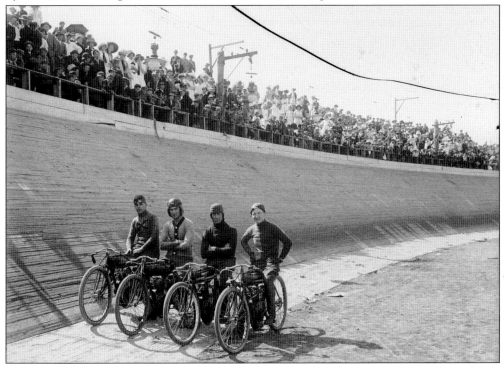

Wandamere Park (now Nibley Park Golf Course) on Seventh East featured this banked hippodrome for bicycle racing. A very popular sport in Salt Lake City at the time of this 1912 photograph, bicycle racing also took place in the original Salt Palace on Seventh South. Large concert bands like those led by John Held and Orrin Sweeten played marches and popular tunes during the races.

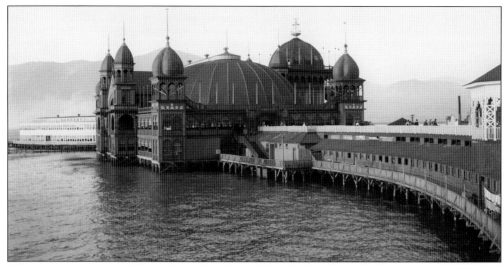

Saltair, an amusement park on the eastern shore of Great Salt Lake, styled after a Moorish pleasure palace, opened on June 8, 1893. It was designed by prominent Salt Lake City architect Richard K. A. Kletting, who also designed the state capitol. Sponsored by the Mormon Church to provide a morally safe recreational environment for young people from Salt Lake City, it became a wildly popular entertainment destination and tourist attraction.

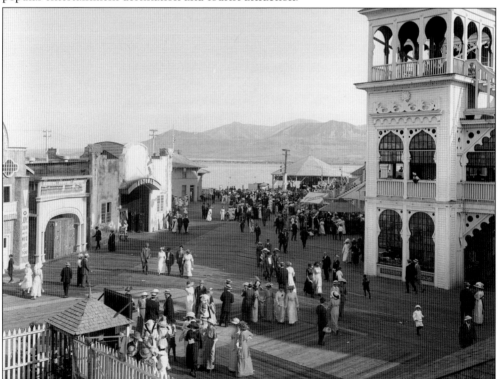

Billed as the "Coney Island of the West," Saltair was part of the Mormon Church's strategy in the 1890s to overcome its exotic image from the 19th century and to present Utah as a normal part of the United States. In the end, though, Saltair was as exotic as anything ever seen previously in the state.

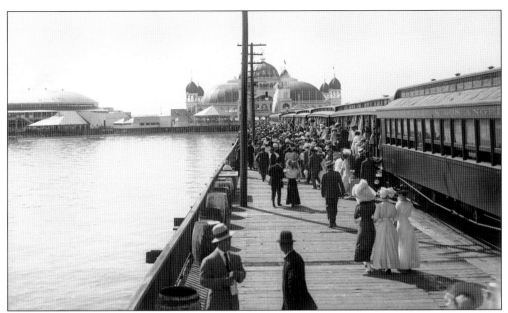

A special railroad line was created to transport the huge crowds of Saltair patrons from Salt Lake City to the resort. Originally called the Saltair Railway Company, the ambitions of its owners soon drove them to change it to the Salt Lake and Los Angeles Railway Company. Although its trestle was eventually extended out into the lake to follow the receding waters, its further extension to California was never built.

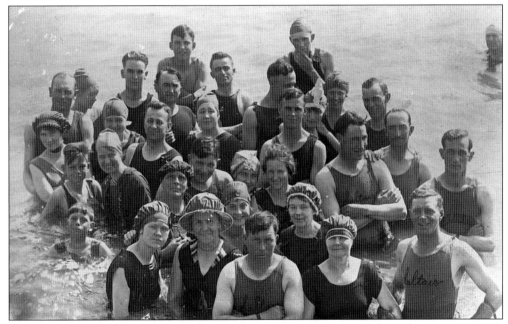

In addition to its celebrated dance floor and carnival concessions, Saltair's big attraction was the opportunity for swimmers to test the famous buoyancy of the lake's highly saline waters. The lake is also extremely shallow, however, meaning that even minor changes in water level make huge differences in the location of the shoreline. The resort could be left high and dry or flooded out.

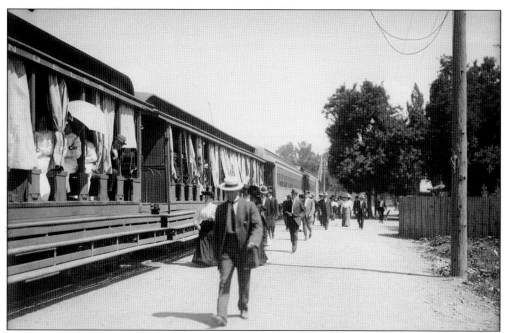

Although some of the cars used to convey people to Saltair were enclosed, others, like these two, were open to the air. In this June 1909 photograph, many customers are already availing themselves of this means of beating the early summer heat, pending their plunge into the lake at the end of the journey. The large crowd on the depot platform also indicates how popular the lakeside resort was.

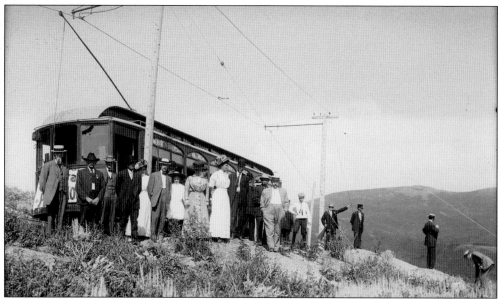

During the period after Emigration Canyon stopped being a pioneer road into the valley and before the development of permanent residences there in the 1950s, the canyon served as an access route for sheep flocks going to the mountains and as a place for valley residents to escape some of the heat on summer weekends. The Emigration Canyon Railroad was built to get them there, with perhaps an overnight stay at luxurious Pinecrest Inn.

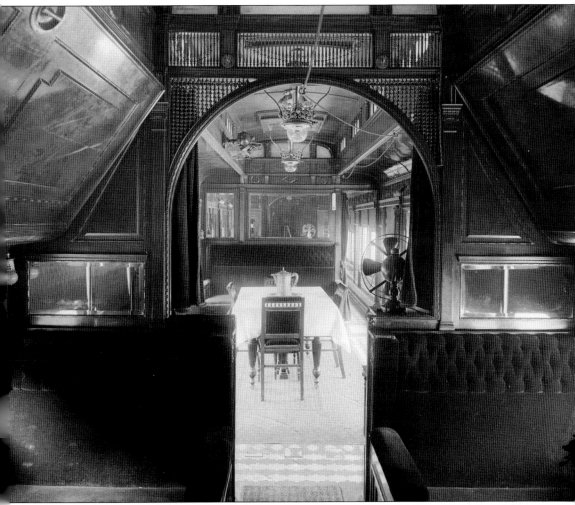

The career of Samuel Newhouse, a son of Jewish immigrants who arrived in Utah from New York City in 1896, symbolizes both the increasing ethnic diversity of the state and its emerging capitalist economy. After making perhaps the largest fortune in Utah mining history, Newhouse settled in Salt Lake City, building a home on South Temple Street, the Newhouse Hotel, and the Newhouse Building on Exchange Place. This photograph of the dining room in his private railroad car shows that he traveled in style.

Lagoon amusement park was built on a natural lake in Farmington, a northern suburb of Salt Lake City, in 1895. Its proprietors, including Gov. Simon Bamberger, had built a resort called Lake Park on Great Salt Lake, but the receding lake water left it surrounded by mud and they decided to move the facility to Lagoon. Bamberger also ran the electric railroad that transported visitors to the resort from Salt Lake City.

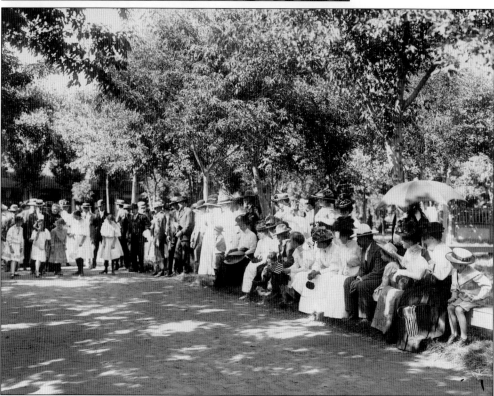

By 1906, visitors to Lagoon could ride Shoot-the-Chutes and the beautiful merry-go-round, swim, row boats, or dance. Today, schools, churches, employers, and other organizations sponsor "Lagoon Days" to show their appreciation and promote team building. It is possible that this group came together for such an organizational purpose. In this 1909 photograph, children line up on the left for a race.

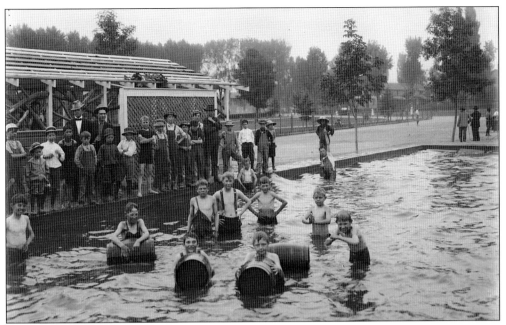

Salt Lake City resides in a high desert environment, giving residents cold winters and hot summers. When temperatures reached the 100-degree mark, swimming was a cheap activity to cool off and keep the kids busy. Pioneer Park, located in downtown Salt Lake City, provided a pool for boys and girls of all ages. In the days before water wings and pool noodles, these children use barrels to stay afloat.

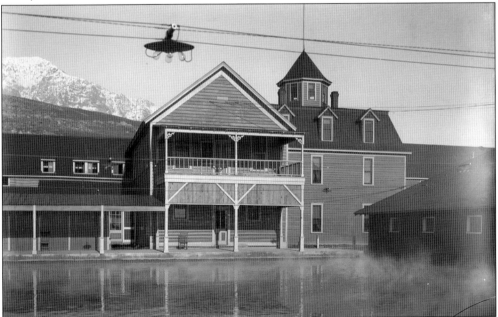

Beck's Hot Springs in North Salt Lake was a recreational facility seen in this 1908 photograph. The shallow lake formed by the outflow of the natural spring in pioneer times actually contained fish, which one enterprising North Salt Laker, Ethan Pettit, used to market in the city. Various bathing and swimming facilities have been erected on the site.

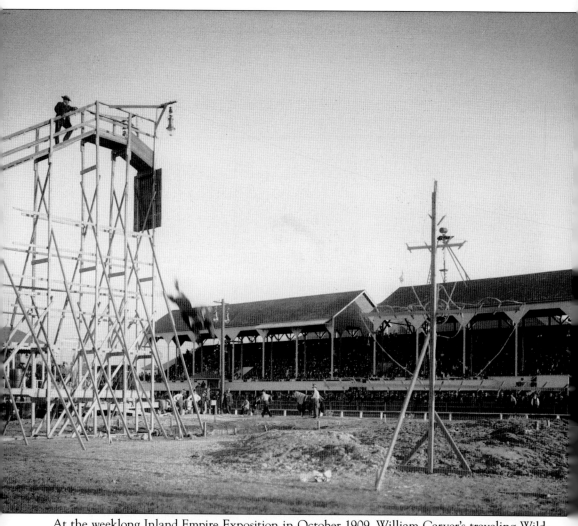

At the weeklong Inland Empire Exposition in October 1909, William Carver's traveling Wild West Show left the crowd breathless. The horse dove from 40 feet into a pool of water 10 feet deep. Decades later, allegations surfaced that riders used electrical jolts, prods, and trap doors to induce Carver's horses to jump. It appears that a trap door forced this horse to jump. By World War II, horse diving shows were a thing of the past.

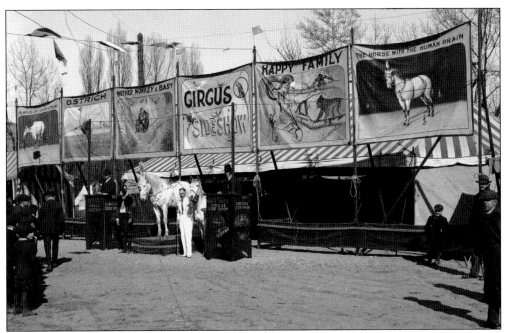

Carnivals such as this one in April 1920 were opportunities for the working class to enjoy leisure activities with their families without spending much money. In the photograph above, a circus sideshow promises a "horse with a human brain," exotic animals such as an ostrich and a monkey, and quite possibly the rarest specimen of all—a "happy family." The image below includes a Ferris wheel and gaming booths. The City-County Building is in the background. The banner at the Ferris wheel asks for support of war mothers, showing that Utahns were still reeling from the personal losses of the Great War.

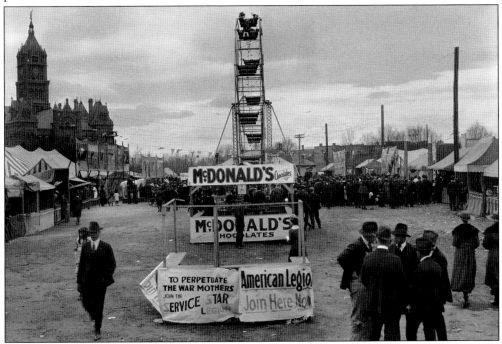

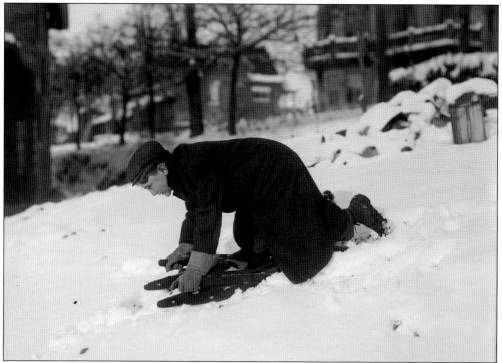

Situated in a high desert, Salt Lake City experiences extensive snowfall in the winter months, so it is no surprise that Utahns have taken advantage of winter recreation. This boy is using a bent-knee sled, which requires the rider to kneel on one knee and push with the other leg. Because it was made of wood, the sled was incredibly difficult to steer.

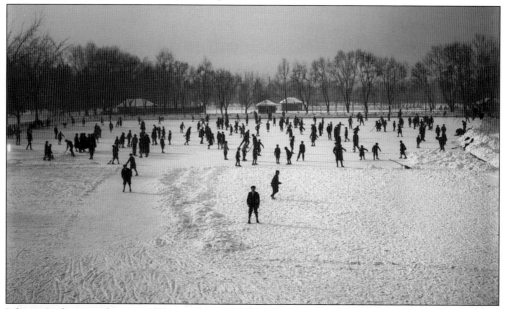

Liberty Park was a playground for residents who lived in the suburbs of downtown Salt Lake City. Winters bring freezing temperatures to Utah, and the park's frozen pond and free admission made it a favorite location for ice skating. Children of all ages are shown skating in this 1917 photograph.

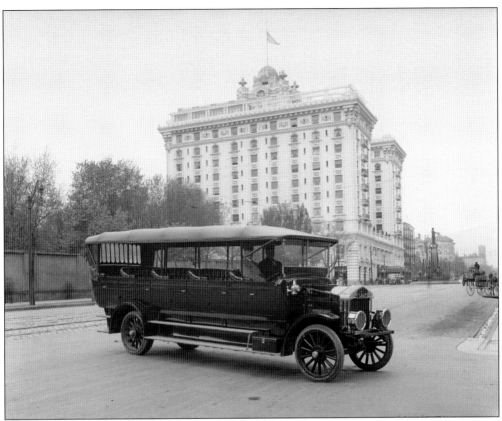

The Hotel Utah, seen in the background of this 1914 photograph, was considered the grande dame of hotels in the region since its opening in 1911. Known for its elegance and first-class accommodations, the hotel hosted business travelers, tourists, and U.S. presidents. At 10 stories, the hotel was built for $2 million through a cooperative effort between business and ecclesiastical leaders in the community.

Those visitors who could not afford to stay at the Hotel Utah could find cheaper accommodations nearby. Places like the American Hotel offered rooms ranging from a quarter to 50¢. Hotel guests could take a bath, get a haircut and a shave, and get a beer within close walking distance.

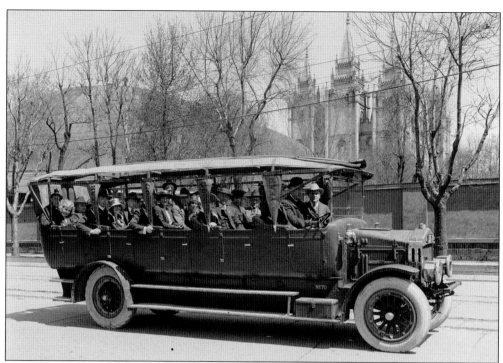

The Salt Lake Temple's completion in 1893 marked a new beginning in the relationship between Mormons and the rest of the country, as the *Chicago Tribune* called it the "St. Peter's of the New World." By the beginning of the 20th century, the Union Pacific Railroad advertised the site as a special tourist destination. This photograph shows a sightseeing car at Temple Square in 1919.

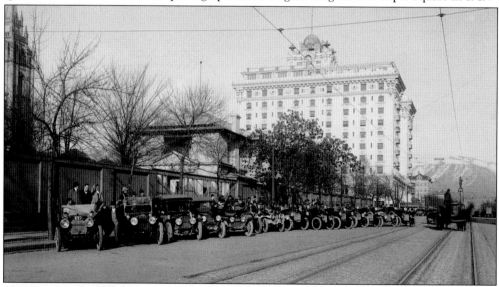

This photograph documents an early spring automobile trip; these local men drove the same car model north to Idaho Falls in 1915. The *Salt Lake Tribune* called Salt Lake City a "central point for all transcontinental touring," which would become especially true once highways connected Western settlements. In the 1950s, Salt Lake City was the stopping point for many families traveling to and from Disneyland.

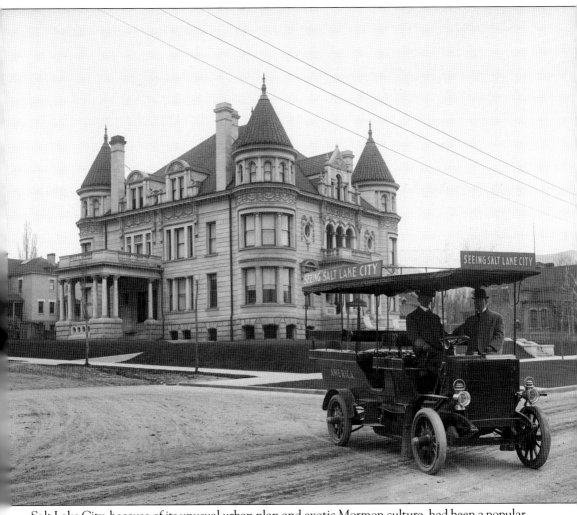

Salt Lake City, because of its unusual urban plan and exotic Mormon culture, had been a popular tourist destination from the mid-19th century. This 1906 photograph shows that it lost none of its appeal even after the rise to prominence of non-Mormon residences like mining magnate Thomas Kearns, whose South Temple Street home is depicted here. The saplings along the street are now huge trees that almost hide the house.

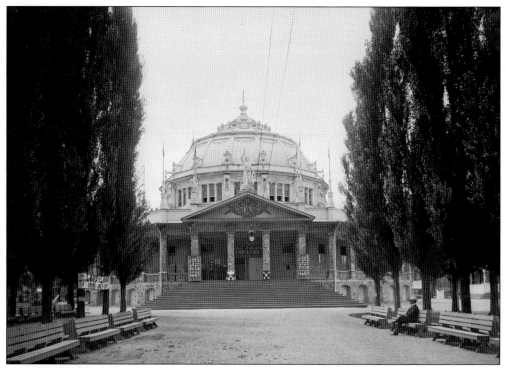

Located on 900 South between Main and State Streets, the Salt Palace Theatre was an ornate symbol of Salt Lake City's lively cultural life as well as an architectural monument testifying to the city's growing wealth. Designed by architect Richard Kletting, who was responsible for a large number of other public and private buildings in the city, it was built in 1899. After a 1910 fire destroyed it, it was not rebuilt, perhaps because of the growing competition from other theaters.

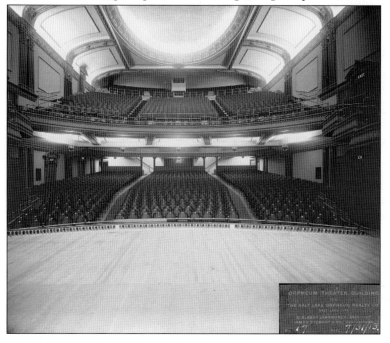

The Orpheum Theatre on 200 South Street was completed at the end of July 1913. This view from the spacious stage into the audience seats depicts one of the city's most opulent and effective theatrical facilities. The Orpheum, renamed the Capitol Theatre in 1927, was part of a major advance in cultural life in the city during the early 20th century.

The huge sign across 200 South Street marking the Orpheum Theatre was for many years one of the monumental features of Salt Lake City urban life. The sign was changed in 1927, when the Orpheum became the Capitol Theatre, and it was later removed altogether. The ornate facade of the building, as well as the interior, was restored in the 1970s, when it became, among other things, the home of Ballet West.

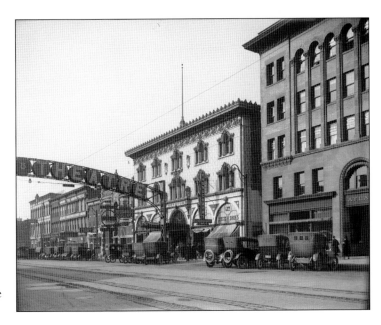

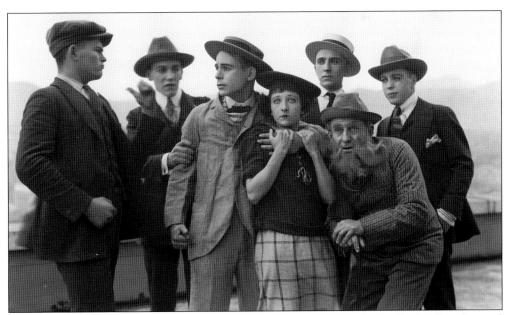

Utah's landscape became an attractive place for filmmakers such as John Ford, who filmed several movies with John Wayne using southern Utah's rock formations as a stunning backdrop. Before Ford filmed in Utah in the 1950s, a few homegrown and Hollywood companies had filmed silent pictures in Salt Lake City for decades. Here, actors from the Variety Film Company pose atop the Walker Bank Building in the 1920s.

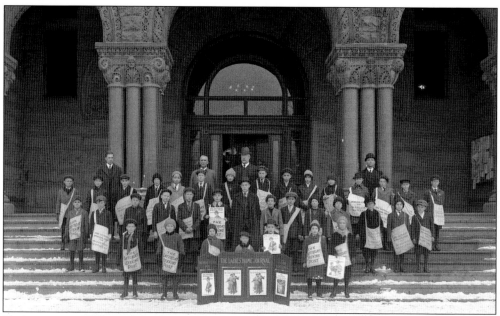

Utah governor William Spry poses with newsboys selling publications of the Curtis Publishing Company on the steps of the City-County Building in 1915. Popular magazines, which were selling for 10¢ a copy by the beginning of the 20th century, achieved mass-market circulation and became favorite outlets for articles by muckraking journalists, who realized that an informed public was a necessary foundation for reform legislation. The *Ladies Home Journal* touted on the poster in front was a prominent muckraking magazine.

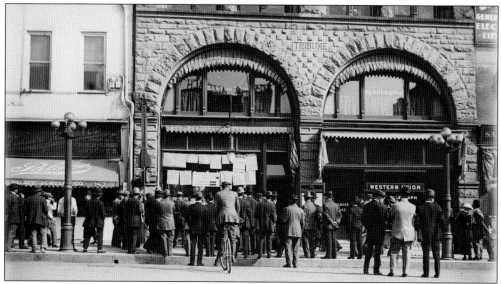

Crowds like this one in front of the *Salt Lake Tribune* office in 1911 were common in the days when radio was in its infancy and the city's sole news source was its newspaper. People would gather at the newspaper office to follow the progress of sporting events as they took place or to read the latest news bulletins posted in the window. As a morning paper, the *Tribune* forced its readers to wait until tomorrow for its full reporting, so gatherings of news junkies like this would have been common during the course of the day.

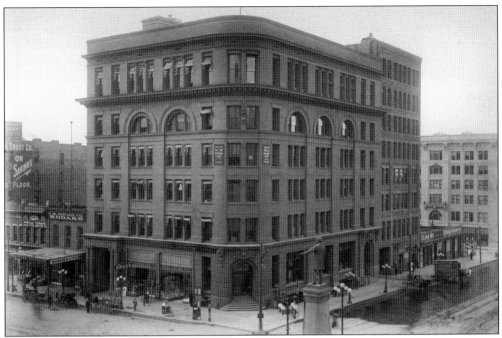

The *Deseret News* and the *Salt Lake Tribune* have a long history of contention. Mormons founded the *Deseret News* (above) in 1850 to serve as a voice for Mormons and their church. In 1870, several dissident Mormons who disagreed with Brigham Young's economic policies formed what would eventually become the *Salt Lake Tribune*. From its inception, the *Tribune* voiced concerns, opinions, and politics of non-Mormon and anti-Mormon residents, and both newspapers provoked the ire of the other. Thomas Kearns purchased the *Salt Lake Tribune* in 1901, and within three years, it was an official voice of the American party. The photograph below shows the *Tribune's* printing presses in 1906.

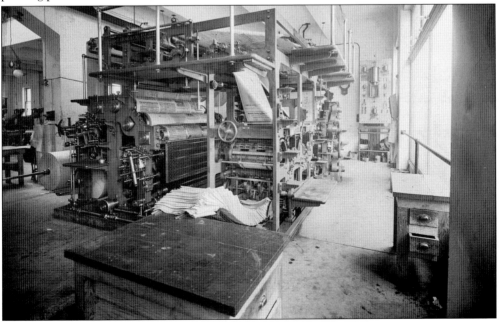

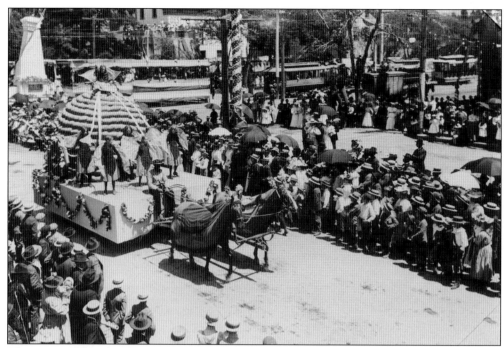

The years 1896 and 1897 were full of celebrations in Salt Lake City. A year after celebrating statehood, Utahns celebrated the semicentennial of Mormon arrival in the Salt Lake Valley. The Pioneer Day Parade winds its way through downtown annually. This beehive float displays the state symbol, a representation of Brigham Young's ideal society where each individual worked for the common good. The hive is surrounded by children in bee costumes. (Classified Photograph Collection.)

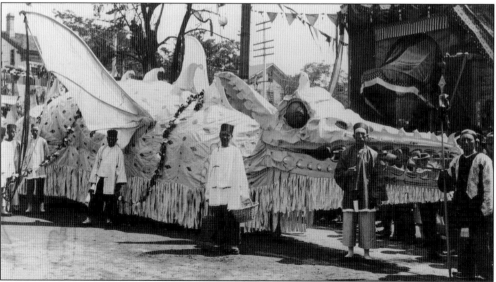

At the Pioneer Semi-Centennial Parade in downtown Salt Lake City, this float represented the Chinese influence in connecting East and West through the Transcontinental Railroad, finished in 1869. However, the men in this photograph are not Chinese, and the float is an inaccurate representation of a Chinese dragon. (Classified Photograph Collection.)

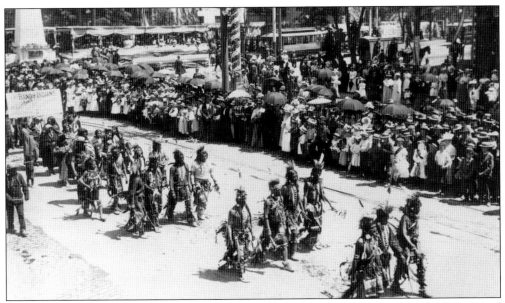

At the 1897 Pioneer Day parade, Native Americans in ceremonial dress represented the original inhabitants of the valley. The sign at the rear of the procession advertises that a "Band of Indians" would perform the Ghost Dance and War Dance at the Fairgrounds that afternoon. Ironically, the Ghost Dance originated in the 1880s during a Native American spiritual resurgence, fueled by the hope that whites would be punished for dispossessing the native people. (Classified Photograph Collection.)

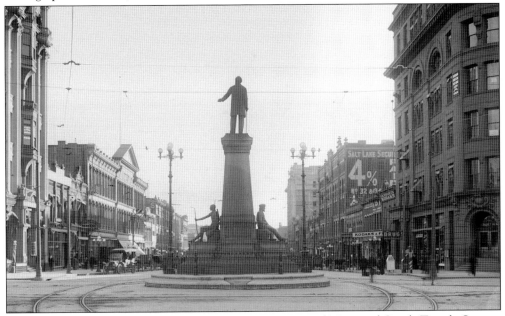

The Brigham Young Monument stood at the intersection of Main and South Temple Streets, the origination of Salt Lake City's unique street numbering system. The 1897 monument reflects contemporary views of culture and race, as Brigham Young, the white man who led the Mormons to settlement, is elevated above the Native Americans (left) and the fur traders (right) who did not settle there. The monument was moved in 1993.

www.arcadiapublishing.com

Discover books about the town where you grew up, the cities where your friends and families live, the town where your parents met, or even that retirement spot you've been dreaming about. Our Web site provides history lovers with exclusive deals, advanced notification about new titles, e-mail alerts of author events, and much more.

Find Your Place in History.